MW00353453

SOUVENIR

SOUVENIR

A Memoir

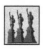

Carole Turbin

Full Court Press
Englewood Cliffs, New Jersey

First Edition

Copyright © 2019 by Carole Turbin

All rights reserved. No part of this book may be
reproduced or transmitted in any form or by any means elec-
tronic or mechanical, including by photocopying,
by recording, or by any information storage and retrieval sys-
tem, without the express permission of the author,
except where permitted by law.

Published in the United States of America
by Full Court Press, 601 Palisade Avenue,
Englewood Cliffs, NJ 07632
fullcourtpress.com

ISBN 978-1-946989-29-1
Library of Congress Catalog No. 2019931748

Editing and book design by Barry Sheinkopf
Cover art, "Souvenir," lithograph, by the author

The author gratefully acknowledges the use of
the following photographs in this book:

p. 50, courtesy of the Leonard Pitt Collection
p. 75, courtesy of the Tamiment Library,
 New York University
p. 101, courtesy of Judith Aron

TO MY HUSBAND, BILL

Acknowledgments

I owe thanks to the many friends who helped me over the twelve years it took to complete this project. An artist and writers' group inspired me to write about my father's souvenirs. Barbara Corrado Pope assured me that *Souvenir* was a good read, and Alice Kessler-Harris urged me to put myself into the story. Alexandra Weinbaum contributed her knowledge of Russian/ Polish history. Doris Friedensohn introduced me to Barry Sheinkopf of Full Court Press, who, over ten years later gave me the impetus to make my story public. Thanks also to friends who commented on the manuscript, including Denise Bergman, Louis Menasche, Daniel Horowitz, and Eva Richter; others who read drafts or just listened to my struggles are too numerous to name.

It was not easy for me, an academic accustomed to keeping myself out of my writing, to write a memoir, which is as much about myself as about my father. I could not have done this without my husband, Bill Miller, who read every draft and never tired of discussing them with me. And I could not have understood connections between my memories and artwork without decades of psychotherapy with Barbara Cohn Schlacket.

Souvenir was in part a family project. Many cousins contributed family lore. Judith Turbin, an accomplished genealogist, tirelessly researched family history and steered me to resources. Thanks to the staffs of the New York City Municipal Archives, New York Public Library, and the New York

Historical Society, I found what I needed to know. My brothers, Rich and Ron Turbin, both read the manuscript, and Rich assured me that the family I wrote about was the one in which he grew up. My cousin, Matt Hartman, contributed his proofreading skills.

I owe special thanks to the Art Students' League of New York. There I did my first drawing of an old sink and recalled that my father instructed me to draw what I feared. I learned lithography from Bill Behnken, Rick Pantell, and most especially, Tomomi Ono, and created prints of childhood memories, including my father's bronze-plated souvenirs.

I am most grateful to Stephanie Golden, my editor, who helped me learn to tell a good story.

Table of Contents

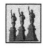

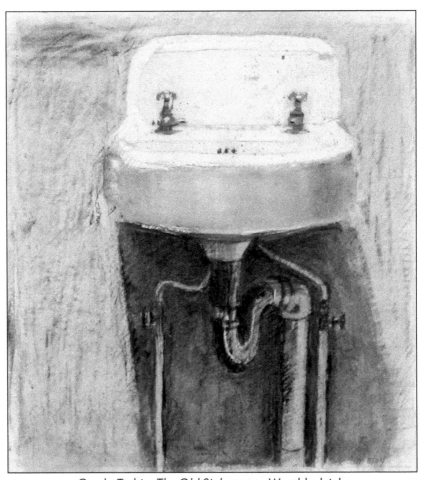

Carole Turbin, *The Old Sink*, 2004. Wax, black ink,
charcoal, and conte crayon on paper.

1.

Prologue:
"If You're Afraid . . ."

I F YOU'RE AFRAID, DRAW IT," my father said. It was a night in 1947; I was five years old and had woken up to go to the bathroom. Peering at the shadowed plumbing beneath the sink, across from the toilet, I imagined that the pipes moved. Terrified, I screamed. My father, who was always the one to respond to my nighttime cries, came to my side. First he berated me for over-exciting my mind by reading too many horror comic books. Then he handed me a pencil and a sheet of paper. I took them, looked at the pipes, and carefully outlined their shapes in pencil. Gradually my terror left me.

For many decades I forgot this incident and my father's words, though even at five I wanted to be an artist, like Uncle Harold, my mother's brother, and drawing was my artistic strength. As a child

I scribbled on any blank paper I could find, including endpapers in books and the cardboard from my father's laundered shirts, continued drawing as an adolescent, and studied art in college. But I knew I couldn't make a living as an artist, so, inspired by the Woman's Liberation Movement, I became a historian of women and college professor. Not until my fifties did I return to art, and found myself drawing pictures similar to the one I had done at five. Only then did I recall my father's words and his having intuited the calming effect of putting pencil to paper. The very act of drawing the angles and joints in shadowed places beneath the sinks in my home released other memories as well. For my parents had told me more than a child should know, and now I recalled most of what they said, even when it was laden with painful emotions. These memories gave me the courage to write this story about my father, my mother, and myself.

My tall, slim black-haired father, William Turbin, born in 1909 on the Lower East Side to Russian Jewish immigrants, had intense, dark eyes and highs and lows of anger, enthusiasm, and melancholy. Often he told me about himself. He suffered. Schoolmates taunted him because he stuttered. He was romantic. In 1938 he met my beautiful mother, Ruth, at a dance that he promoted. He named me for a movie star, Carole Lombard, who died in a plane crash in 1942 just before I was born. He had a shadowy woman friend who he claimed was an Indian Princess. He was wily. He hated having a boss. He believed in racial equality.

His realm in our home in Flushing, Queens, the basement, was a child's fantasy. There he packed novelties and souvenirs of New York City, bronze-plated Statues of Liberty and Empire State Build-

ings, which he sold to newsstands, variety stores, and tourist shops in midtown hotels, Times Square, Chinatown, and the West Side piers. He referred to these shiny metal models as "my" souvenirs, and I thought of them that way too.

I adored him, though I was terrified of his angry outbursts and occasional slaps, which seemed to come from nowhere. Often, after

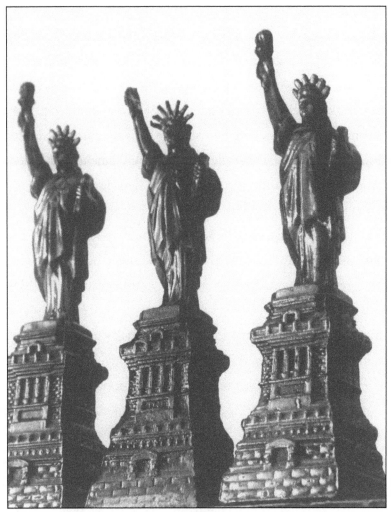

Three bronze-plated models of the Statue of Liberty.
Photograph by the author.

raging at my mother, he slammed the front door and disappeared for a few days. I feared he would never return. My mother, so lady-like and poised when playing Chopin on the piano, was no match for his red-faced, often crude fury. She never showed anger. But in private moments, in quiet, even tones, she confided in me about my father's failings, her immigrant parents' struggles, and her disappointments.

When I was about six, I became aware that I resented his anger. After one eruption at me, I ran upstairs to my room and shut the door. Soon I heard his footsteps; he was on his way to apologize, as he had many times before. I had always forgiven him. He entered my room without knocking and said, sheepishly, that he was sorry he'd lost his temper. This time I was furious that he had yelled at me when I'd done nothing wrong, and felt that his expression of regret was meaningless because he would yell at me again for no reason. So I retorted, sharply, "I knew you would apologize." That was the last time he said he was sorry after an angry outburst at me. I didn't forgive him until he was an old man of eighty-five, and I was fifty-two.

Even as I forgave him I understood that I was like him—tall, slim, intense, and with a volatile temper. By then I thought I knew him. He was the quintessential salesman, an occupation characteristic of his time, immortalized in Arthur Miller's Death of a Salesman. Yet he had none of Willie Loman's tragic desperation. During the Swing Era he promoted dances, selling the promise of a cheap evening of romance. From the 1940s to the mid-1980s he marketed "his" souvenirs, objects carrying memories of iconic places. And he sold his charms to my mother, to me, and, until he was ninety-two,

to many other women.

He was also an illusionist who called himself the Great Turbino. Until he died in 2005 at ninety-six, he applied his selling skills to magic. When he performed, at libraries and hospitals and for anyone he encountered on the street or in restaurants, his face was animated and his eyes sparkled. Like any magician, he didn't reveal his secrets. In a notebook he jotted down the Fool's lines from Shakespeare's King Lear: "Have more than thou showest, speak less than thou knowest."

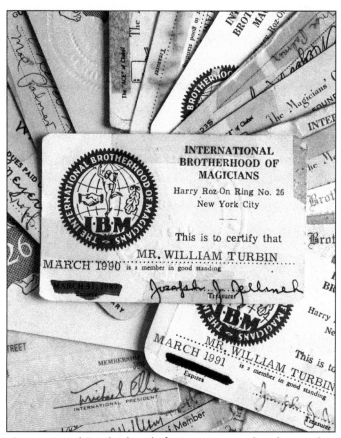

International Brotherhood of Magicians membership cards.
Photograph by the author.

After he died I learned how little I actually knew about him. I discovered that he had documented his life in diaries begun when he was eighteen, short stories, and essays. He had filled albums with his rhyming poems, letters, photographs, and publicity for his dances. As a historian, I saw this as a goldmine, an unusually complete archive for someone who was unknown. So I set out to write his story. To this trove, I added tape recordings I had made of his tales, and recordings my cousins had made of interviews with my father's mother and his two sisters. Later, by digging into other archives with the help of a genealogist cousin, I learned that my father and his family had remarkably accurate memories.

When I taped my father's stories, he began by warning me, "Are you ready to hear about the seamy side of life?" By that time, a senior citizen myself, I was ready for anything. It was when I learned his hidden secrets and began to put words on paper that I realized that I was writing not only a story about him but also about myself. Only then did I lay him to rest.

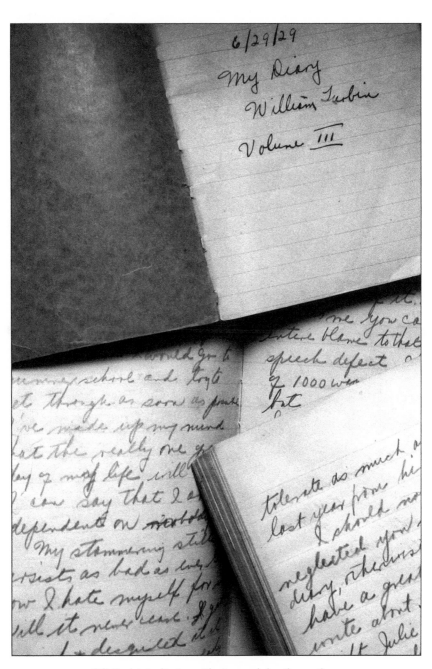

Bill Turbin's diaries. Photograph by the author.

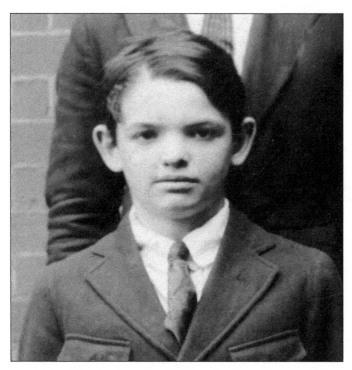

"Little Billy," 14, in a school photograph, January 1923

2.

Little Billy

In 2003, when my father was ninety-four and in relatively good health, he told my two younger brothers and me that he wanted us to engrave on his tombstone the words He lied. He stole. He cheated. But he meant well. A few months later he asked for He slept with a nun, which he considered his ultimate sexual conquest. (After my mother died, one of his lovers was a nurse and former nun.) In the end he chose to twit convention by applying to death, life's most serious moment, a bland, trivial phrase: Thanks for the visit. Have a nice day.

His funeral was a not a mournful affair. The spacious room was filled with my brothers and our friends, many of our seventeen cousins and their families, and a few old folks. The rabbi, who had never met my father or any of us, gave no eulogy. My husband, Bill, took the stage first. He said that Bill Turbin reminded him of the Reader's Digest column "The Most Unforgettable Character I Ever

Met." My brother Rich reminisced about how my father had paid us and our cousins to glue green squares of felt to the bottoms of bronze-plated models of Statues of Liberty and Empire State Buildings in our basement. I spoke about my father's contradictions: "He preached vegetarianism but loved sausage and hot dogs." My brother Ron said that his father "had many flaws," but that his "best quality was that he did not try to hide them. He was not a phony."

My first memories of my father are stories he told as he took me by the hand to buy tomato plants at the neighborhood nursery in the spring, or to a park. He had a sonorous voice with a former stutterer's hesitations and rapid-fire speech. He was so hungry to be heard, so anxious to get the words out, that he rarely paused for a response. As I listened, I relished his dark-eyed intensity and felt immensely significant because I was the center of his universe.

Looking back now I can't distinguish between those tales and what I later read in his writing. Some stories are about a boy growing up on the crowded, "steamy" Lower East Side who suffered from hardships and boasted of overcoming adversity. The first story I remember is about the accident that resulted in his shapeless nose. A favorite boy's game was climbing the steps of a building, ringing the doorbell, and running away to hide. One boy, who was too short to reach the bell lifted Billy, the smallest and lightest. When someone opened the door to see who was there, the boy dropped Billy, who fell and lay there bleeding from his nose and screaming in pain. He was taken to a hospital where a doctor removed the shattered cartilage.

In a story titled "Little Billy," he explained why he had poor vision. Boys thrilled to hanging on to the rear railing of the electric

trolley that ran on main streets like Delancey and Second Avenue. Nine-year-old Billy was reluctant to risk falling or being accosted by a police officer, but a more confident friend urged him that, if he didn't try, he would "never know." He climbed on to a moving car and hung on "for dear life." When he saw a policeman, he panicked, jumped off, fell, and lost consciousness.

He opened his eyes to find himself on the floor of a pharmacy near his friend, bystanders, and a woman trolley conductor in an "oil-spotted khaki uniform." (During World War I, trolley companies hired women because men were away.) Billy claimed that the conductor had pushed him; she protested that that was impossible because she was "in the front of the car." The "rookie" police officer pressed no charges because no one had been harmed. But when Billy left the store, street signs were so blurry that he had to find his way home by recognizing familiar buildings. In the evening, as he got into the bed he shared with his older brothers, he bragged about his exploits.

The next day he could no longer see well enough to play street stickball or read titles of silent films, which he loved. In school he could not see what the teacher wrote on the blackboard, even from the front row. He refused to admit this because another boy who wore eyeglasses was taunted as "the perfessor." To pass school eye examinations, he memorized the charts. And he devised reasons for sitting in the back to have an excuse to walk up front to see the blackboard. As the teacher wrote, he concentrated on remembering what she said. Once she called on him to subtract one multiple figure number from another. He strained to recall what she had said, first the numbers on the right then the others, and answered the

question. The teacher said he was correct, but wondered, "Why did it seem so difficult?"

He already suffered from stuttering, as he often reminded me. When he said his name, it came out "Tut-tut-turbin," so his schoolmates snickered and called him "King Tut," whose tomb had been discovered in 1922. To avoid humiliation, when a teacher asked a question, he often replied that he did not know even if he did. He did so badly in school that he was demoted from a class for students who had done well on an IQ test.

Finally, the principal called him to his office and demanded to know why "such an intelligent boy" did so poorly. He "blurted out" that he could not see the board. The principal informed his mother, who took him to a clinic. On his first day of wearing glasses, he wasn't humiliated by taunts as he had anticipated, but surprised at the pleasure of seeing. He recognized people from a distance. Watching movies became "a passion." Twice he saw The Big Parade, a silent film with John Gilbert and Renee Adoreé. He boasted that he became a risk-taker. Since day-to-day difficulties seemed minor compared to what he had gone through, he brushed away problems like "water off a duck's back." Friends asked him how he "had the nerve" to do this or the "courage" to do that.

He also boasted to me and my brothers that his ancestors had been portrayed in a Broadway play, The Days of the Turbins, which, he claimed, was about rulers of Russia before the Czars. Mikhail Bulgakov's play, a favorite of Stalin's, was indeed produced in New York in 1962. Bulgakov, born in Kiev in 1891, adapted it from his autobiographical novel, the White Guard (1925), about Kiev in 1918. The main character was not a ruler but a highborn physician,

Alexei Turbin, whom Bulgakov named for one of his relatives. At other times my father claimed that the family name was not Turbin but Turbillo. In fact, his grandfather, Morris Turbin, was born Mordechai Gimple Torbilo in June 1834 in Buki, south of Kiev. Mordechai Torbilo must have known of aristocratic families named Turbin in Kiev, so he took the name before departing for his new life in America.

According to family lore, Morris was in the Russian army and fought in Sevastopol during the Crimean War in 1854. He was discharged, the tale continues, after twenty-five months because his wartime service was equivalent to twenty-five years, which is what young Jewish men were expected to serve in peacetime. In 1872, about eighteen years after leaving the army, he married Mollie Grossman, who was born about 1842, probably also in Buki. The government had awarded him a pension, and he planned to buy a dacha, or country home, something that was out of reach for most Jews. But an older son persuaded him to use the money instead to emigrate to America.

Morris, Mollie, and their nine children were among thousands who fled Czar Alexander III's repressive policies and violent pogroms. In 1891, at fifty-eight, older than most immigrants, Morris traveled to Rotterdam and boarded the SS Obdam to Castle Garden. The following year Mollie and the children sailed on the SS Etruria, disembarking on July 11, 1892, the year Ellis Island opened. In a photograph from the late 1890s Morris and Mollie appear partly secularized. Mollie, like most immigrant women, wears no corset, but neither does she wear the wig required for Orthodox wives. Morris, just short of six feet, wears a hat and full beard, like

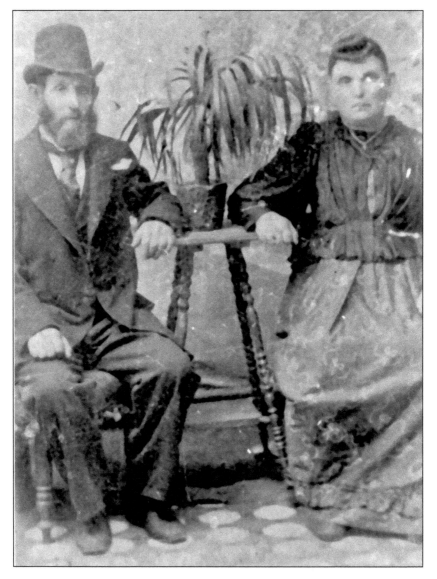

Morris (Mordechai) and Molly Turbin, mid 1890s

other Jewish men. Otherwise he dresses like an American, in a ready-made suit (ill-fitting because a good fit was costly, available only from a tailor), a fashionable bowler hat, and a white shirt with a detachable wing collar.

My father also bragged that his father, Sam—Morris and Mollie's seventh child and fourth son, born January 14, 1884—began life in America not as a lowly peddler or garment worker, but as a farmer. In fact, for two years Sam and his four brothers helped work a farm in Oakdale, Connecticut. Morris purchased the farm in May 1897 with the help of a low-interest loan from the Baron Maurice de Hirsch fund, which helped Eastern European Jews settle in agricultural areas rather than crowd into congested cities. He sold it in 1900 and began a dairy in Eastchester in the rural Bronx, which in those years supplied city dwellers to the south with vegetables and dairy products. In 1903, Morris Turbin Milk, on Middletown Road, had ten cows. In 1905, Morris moved his business a few miles southeast to Reed's Mill Lane, in an area that later became the site of the Co-op City housing project.

In 1905, Sam, who was his father's business partner, married Pauline (Pessel) Belfert, a Ukrainian immigrant and daughter of a yeshiva teacher. A year later the family gave up dairying. My uncle George, a lawyer who knew about such things, recalled that they couldn't afford the cost of pasteurization and other regulations, which were required by the new Pure Food and Drug Act. So Sam, now married with two children, went into the furniture business with a relative, Jacob Aronofsky, and then ran two stores with a Belfert in-law. By 1927 Sam had his own enterprises—S. Turbin and Son, on Avenue C, and another on Houston Street.

According to my father, Sam was "ignorant and illiterate," his mother was neglectful, playing pinochle all day, and they lived in cold-water flats, like the one where he was born in 1909, with a midwife's help. The building, on East 20th Street between First Avenue

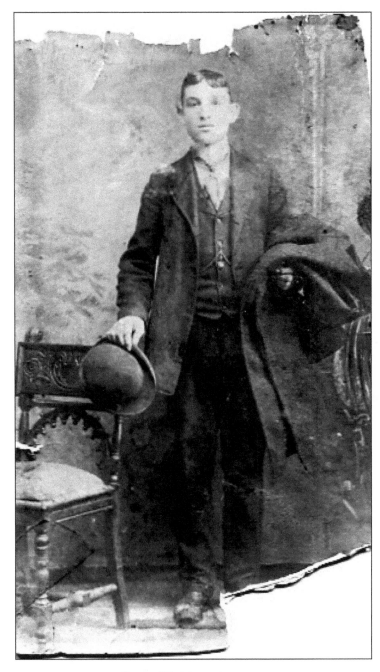

Samuel Turbin, 19, in 1902

and Avenue A, was in the Gas House district, known for nearby leaky tanks and gangs of Irish youths. The flat was on one floor of a former single-family home, which had stairs to the front door like those my father and his friends climbed to ring doorbells and run away. The stairwells smelled of tenants' shared toilets and the windowless interior rooms were full of fumes from oil lamps and gas stoves used for cooking and heating.

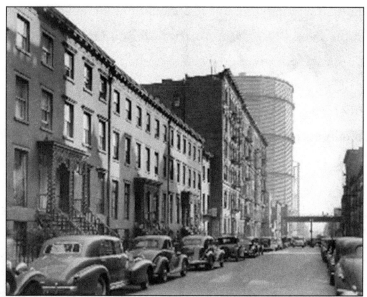

East 20th Street, where my father was born in 1909, looking east toward Avenue A and the Gas House District storage tanks in 1938. Photograph by Berenice Abbott.

My father's younger sisters, my aunts Marian and Bertha, told me that the family was prosperous. Sam's business did so well that in 1923 he purchased 330 East 4th Street, a five-story apartment building between Avenues C and D, across the street from Public School 15. Now the Turbins and their twelve tenants enjoyed central heating, electricity, and a bathroom with a tub and hot running water. At first the family lived in two ground floor apartments.

Later my father and his older brothers, Charlie and George, slept in rooms on the fifth floor. Sam and Pauline collected relatively high rents, forty-seven to fifty-five dollars per month, and hired a superintendent from the Bahamas. They had an upright piano, a major status symbol in those days, and Marian and my father learned to play. In hot summer months they rented a bungalow in Coney Island, a few blocks from the ocean. About the time that Sam bought the house, the family posed for a studio photograph, showing the world their good fortune in America. Billy, in the top row on the right, appears sad, with narrowed eyes and pursed lips, perhaps because of his stuttering and poor vision.

Prosperous as they were, they lived like other immigrant Jews. The family's language was English, but the children learned Yiddish

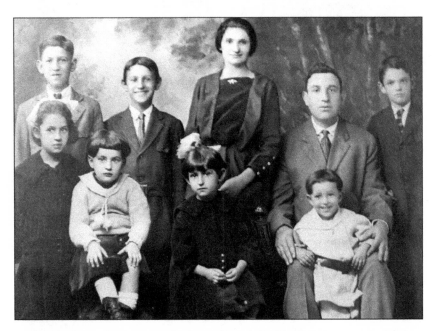

The Turbins, about 1920. Clockwise from left: Charles, George, Pauline, Samuel, William, Isadore (Irving), Marian (Minnie), Bertha, and Mollye.

from their parents and other relatives who lived nearby. My father and his brothers had bar mitzvahs, modest ceremonies in a rabbi's study. Pauline kept kosher and fasted on Yom Kippur while Sam took the children to a restaurant. He and Pauline expected their children, especially the boys, to earn their own pocket money and also contribute income. By age eleven my father worked in the furniture store and was a clerk for a newspaper, The Evening Mail. He gave his mother some of his earnings and kept the rest for himself.

Besides being the mother of seven, assisting in the store, and playing pinochle (but not all day as my father claimed), Pauline was active in politics. She read the Yiddish Forward, a Jewish-American daily affiliated with the Socialist Party. As a loyal Democrat and "ward heeler" (district leader), she helped Tammany Hall maintain influence in the Lower East Side in exchange for patronage. According to my father, when he failed a driving test she pulled strings at the Department of Motor Vehicles to get him a license. As a delegate to the July 1924 Democratic Party Convention in Madison Square Garden, she heard Franklin Delano Roosevelt nominate Al Smith, the Governor of New York, for President. A few years later she became a Republican in order to work for Louis Lefkowitz's campaign for State Assembly (1928 to 1930). Lefkowitz was Jewish, and Republicans controlled federal patronage, including civil service jobs, which were coveted for their security and relatively high pay. She was rewarded with a job for her oldest son Charlie as a post office clerk.

My father must have valued his years at Seward Park High School, because he preserved his senior year magazine. Indeed, in 1927 a high school diploma was equivalent to a 1950s college de-

gree. The magazine featured student artwork, stories, poems, and photos of clubs with budding journalists, businessmen, musicians, actors, chess players, and academics. "Lanky Bill," in class 8-1, led by Dr. Schleifer, belonged to the Service Squad, the Almanac Club, and the track team. He was one of almost three hundred seniors, mostly Jews and a few Italians, most headed for tuition-free New York City Colleges.

When he graduated from high school in June 1927, Bill got a job packing merchandise in cardboard boxes in the basement of a local store, Benson and Greenberg. At this "tiresome" job, he earned five dollars per week and, after a few months, asked for and received a dollar raise. On Sundays he opened his father's stores, collecting payments from installment plan customers. The following December, Mr. Greenberg fired him—he doesn't say why.

In the evenings, my father attended college classes. His grades were too low to qualify for the day session, he had no professional ambitions, and he disclaimed the value of book learning—common sense was more important. Still, he admired his sister Bertha, who graduated as valedictorian at Hunter High School in June 1932 (Eleanor Roosevelt introduced her to the audience). And he retained a few tidbits of learning from high school. He would say that he didn't understand a word of Shakespeare but also praised him as the "world's greatest poet." Once, to improve my diction, he made me memorize Portia's speech from The Merchant of Venice. To this day I can recite the first five lines from memory.

In September 1927, when he returned home from his first class, he wrote on the first page of a notebook, William Turbin, My Diary. His first entry reported that, during class, an "impertinent" remark

"slipped out," and the teacher, "a collegiate young fellow," whom he admired, called him a "wise cracker." He apologized, knowing this was not a good beginning. Reading this, I recognized one of his uncontrolled outbursts, which he later described in his diary as his "rotten temper." He vowed to overcome it because "keeping cool is essential to business and social success." He did not succeed.

I was surprised to learn that he was aware of his temper. He had always adamantly denied his outbursts and claimed that he was cool and collected because he repeated to himself daily, "Never let anything bother me" and "I shall remain calm and collected at all times." He believed in Emile Coué's theory of autosuggestion, which he must have read about in the late 1920s. Coué held that, through reiteration, silently repeating a significant phrase over and over again, one could penetrate the subliminal level of the self and harness the powers of the subconscious to resolve personal and even physical problems.

Bill's grades were mostly "C" or failing. In class he often struggled to stay awake or his mind wandered, often to his diary. During an economics lecture he wrote that, because of his poor vision, when he attended a dance he couldn't tell from a distance if a girl was "homely." If he moved closer to see her clearly, she would notice him and it would be too late to turn away. He received "B" on one English essay, which the instructor noted was "for content not execution." The first sentence was, "I am a stammerer." He wrote that his parents mocked his speech, claiming that it was the best cure, but that this made him feel that he was inferior. To hear kind words of thanks, he did people favors, but when he did this too often he felt demeaned, "like a slave." Especially with girls, he was "ashamed

of his facial contortions," which were "mute evidence of internal horror." He even contemplated ending his life by "walking into the ocean" or "jumping off a chair with a rope" about his neck.

Once he wrote in large capital letters that he was determined to

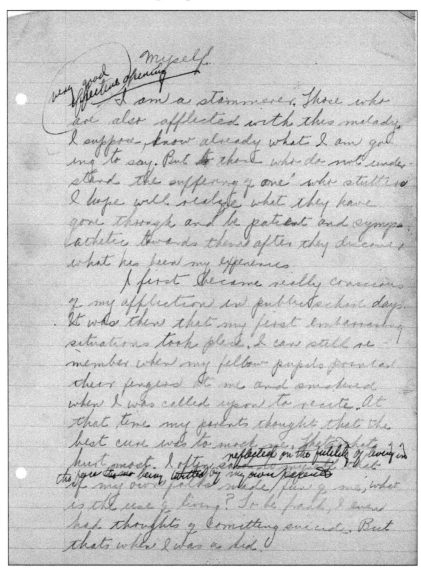

My father's essay on stammering for his first college English class

"turn over a new leaf" and put more effort into school. He tried a Columbia University home study course but didn't keep up with the assignments. Once he convinced his little brother, Irving, to do his homework while he went to a party. In 1930, at twenty-one, he decided that college was "not worth" his "time and energy" because he was not studying for a "particular vocation."

He often claimed that he had intended to become a door-to-door salesman because it was "the hardest possible job for a stutterer" and he "was determined to overcome it." In truth, he backed into selling and was surprised at his success. Since he had once worked after school as a clerk, he applied for similar employment at New York Edison, the City's largest electricity supplier. The company offered him a "canvassing" job with Sunbeam, its appliance division. His task was to carry samples of electric toasters and irons door-to-door and demonstrate them to housewives.

At eighteen he would not have known that selling was a good job for a young man. Salesmen were highly respected and visible. Advertising, which capitalized on new methods of reproducing images, was an emerging marketing tool, but its new media—magazines, newspapers, and radio—lacked the dynamic appeal of live demonstrations and did not reach rural areas or those too poor to pay for radios and periodicals. So men like my father carried sample cases of products door-to-door, displaying merchandise to housewives or local department and general stores. Utility companies like New York Edison manufactured and marketed irons, vacuum cleaners, and toasters because these items increased electricity use. Salesmen extolled the benefits of sleek, shiny steel appliances that promised to transform a housewife's home kitchen into a modern,

clean, efficient workplace. Like my grandfather's business, companies offered buyers affordable installment plans.

At first when Bill knocked on strangers' doors, his "knees quivered" and his "heart throbbed." He often worked in Harlem, a thriving black community. He bragged that, within a few weeks, six months after his eighteenth birthday, he averaged thirty-five dollars a week, which was high for a young man in his situation. Soon he broke company records, earning more than fifty dollars weekly, and was promoted to crew manager. In February 1928, he noted jubilantly that he had not stammered during his acceptance speech and was envied by other salesmen. "Before, I was afraid to speak for fear that I'd stutter, but now, to hell with it, I am going to say what I want even if I do not say a word straight." His success fired his ambition "to conquer the world."

When he was selling, spoken words came more easily to him because he was role-playing and performing. Typically, stutterers are more fluent in situations with clear boundaries, such as singing or talking on a telephone, than in intimate conversations. As he praised shiny electric irons, toasters, and later souvenirs to customers, he created a confident persona. Determined to improve even more, in December 1931 he went to a clinic at the National Hospital for Speech Defects. And he was encouraged by newspaper stories about the Duke of York, later King George VI of England, who had conquered his own stammer.

For Bill, writing was a means of self-expression in which words flowed smoothly without anguished hesitations. By objectifying his unuttered agonies, putting them on paper, he placed them outside himself, and gathered courage to knock on strangers' doors, role-play as a salesman, and later fool the world as a magician. He

taught me this lesson when he handed me a pencil and piece of paper and commanded me to draw shadowed pipes. Though he knew nothing about art, he understood that I could subdue terrors with images rather than words.

My father often bragged that he was employed throughout the Depression, but in truth he had ups and downs. In December 1928 he quit New York Edison because he didn't want to move to Cleveland, Ohio, where the company had relocated the Sunbeam division.

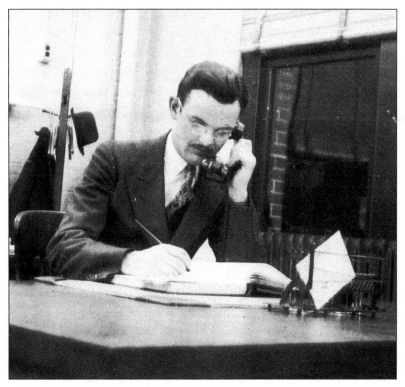

My father phoning a customer, about 1930

The following month, he was hired by another utility, United Electric, Light, and Power Company, for a more desirable selling position. He earned a salary as well as commissions and didn't have to

carry heavy samples from door to door.

Two months later, in April 1929, he was unemployed again—he doesn't explain why. For a few months he probably worked in his father's business. Once he told me that, on rainy days, he sold umbrellas to passersby on the street. That September, a month before the October 29 crash, he returned to New York Edison. Perhaps he re-applied for a job, or they contacted him. Again he was successful, winning a Parker fountain pen as second prize in a competition selling Westinghouse irons. By November he was out of work again.

Now he confided to his diary that furniture would be his "livelihood." Sam had called his business Samuel Turbin and Son because he assumed that one son would be his partner, as he had been for his father in the dairy. Charlie joined first (this was before he became a post office clerk) but soon quit in anger. My father believed that he could do better and not lose his temper, as he had a few months before, when Sam had refused to give him money that he needed "badly." He had erupted in anger, making "rash, ridiculous" statements. However, three months later, his anger once again got the better of him and he too quit, furious. Sam had agreed to hold his wages until needed, but then refused to pay him when he asked for them, claiming that he had given his son more than he could possibly give him. In his diary, my father disagreed. He calculated that he had contributed enough to make up for what he had received, because since age eleven he had given his father part of his earnings.

Shortly afterward he returned to New York Edison, and in 1930, at twenty-one, rented a furnished room near the beach in Coney Island, which he loved. One diary entry began, "Yippee, Coney Island opens next weekend." In November he moved to 2nd Avenue near

the Loew's Commodore Theater. His room was "heaven," with a double bed with "a silk floss mattress" and his own "dresser and wardrobe." On Sunday morning he could sleep late "without being rudely awakened" by one of his brothers.

Perhaps Sam was reluctant to pay his son partly because, during the Depression, his business was declining. In 1931, at forty-seven, he closed the stores and crammed unsold stock into the apartment building. A large, strong man, he lugged chairs and tables up several flights of stairs. He sold the furniture to pay expenses and debts, started a trucking business, and since this was during Prohibition, ran a speakeasy in the basement of the building. He purchased liquor from bootleggers; many were Jewish and involved in other shady dealings.

The Turbins were fortunate. Their assets were in real estate, not savings, which many families lost when the banks failed. They owned their home and rented nine apartments, though Pauline complained that Sam was kind, too kind; unlike many landlords, he didn't evict tenants who were unable to pay rent. Mollye, Bertha, and Marian worked while attending Hunter College, and my father, who was employed full-time, helped George pay his law school tuition. George passed the bar examination in January 1931.

Mollye, Marian, Bertha, and Irving, like their mother, were active in politics—not as Democrats but in Communist youth organizations. Bertha volunteered at a settlement house, probably Henry Street. In August 1939, she stood on a chair on a Lower East Side street corner defending the Hitler–Stalin non-aggression pact. Her burly father stood nearby to protect her. Irving had adventures. In 1933, he quit high school and rode the rails for months, visiting

Chicago and Mexico. He carried with him a list of Jewish families who were willing to provide a fellow Jew with a meal and bed for the night, which he probably got from members of his Socialist youth organization. On his return he worked as a cashier and then a cook in a left-wing coffee shop, and organized entertainment for his socialist organization, which was how he met Woody Guthrie. During the war years he joined the merchant marines and almost lost his life when his ship was torpedoed. That's another story.

My father flirted with the left. At nineteen he paid seventeen dollars for a week's summer vacation at the Communist-run Camp Nitgedeiget (in Yiddish, "No worries"), in Beacon, New York. He wrote that he was "almost a Communist" because the "people are so sociable, intelligent and fiery." I knew him as a New Deal Democrat and advocate of racial equality. As a salesman in Harlem he sympathized with black people's plight and joined the National Association for the Advancement of Colored People (NAACP). He boasted that, at a convention, he had shared a room with Roy Wilkins, later an executive officer, and he praised Eleanor Roosevelt for proposing to integrate the armed forces. In 1968, when Martin Luther King was assassinated, he submitted his poem, "Dr. King" to The Amsterdam News, New York's leading black newspaper. He maintained, proudly, that the editor assumed he was black.

A man had a dream and the dream was sublime.
It told of the end of a dastardly crime.
It told of the man who looked and was shocked.
At lives that were shattered and souls mocked.

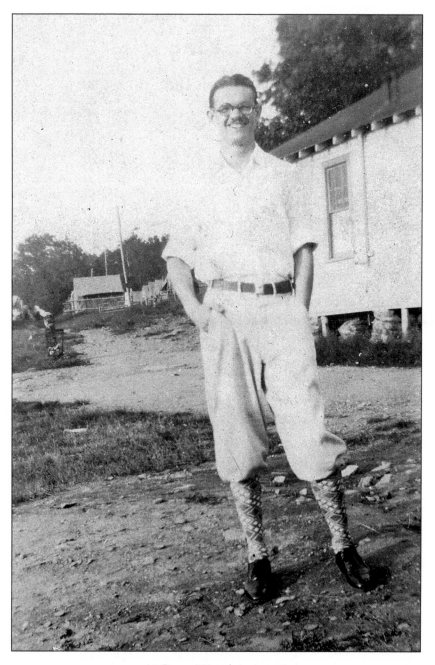

At Camp Nitgedeiget, 1928

Dr. King

A man had a dream and the dream was sublime
It told of the end of a dastardly crime
It told of the man who looked and was shocked
At lives that were shattered and souls mocked
The people had come regardless of will
To a life that remained eternally still
They sweated and suffered till "dawn's early light"
But still no sign of the end of their plight
This man with the dream, he worked and he prayed
The struggle went on, his hopes did not fade
From 'morn till night, he marched and he taught
With spirit his weapon he ferociously fought
The time is now, but the King is no more
Will we really understand what he was fighting for?

BILL TURBIN

My father's Dr. King poem

In his diary, he wrote about romance, not politics. At eighteen he adored his sister Mollye's friend Helen, who "delighted" him by playing the piano when she visited. For two hours they strolled from Delancey to Houston, to 2nd Avenue, uptown to 14th Street and 4th Avenue, and back to Delancey. Later Helen rejected him for his friend Samuel. He was bolder with Fritzi, a neighborhood girl. After a Christmas Eve party, he walked her home and tried to kiss her in the hallway of her building. She resisted, so he turned to depart. As he was leaving, she asked if that was a "way to say good night" and opened her overcoat. They embraced, and his "lips were on her neck, her eyes, her nose and her lips." He was tempted to say he loved her but held back because he did not want to promise to marry her.

That was the first of countless seductions. He met girls at dances at the Democratic Club in Tammany Hall, near Union Square, and the Hotel Pennsylvania opposite the old Penn Station. He went with friends on "picking up trips" to Central Park and Brooklyn—Williamsburg, Prospect Park, and Coney Island. Most were Jews—Jean, Florence, Helen, Annette, Edith, Silvia, Shirley, Sarah, Stevie, Betty, Belle, Esther, Ethel, Ann, Edna, Fay, Jeanette, Minnie, and Rose. Others were "shikses"—Sonia, Doris, and tall, blonde Elsie, who tried to resist his kisses and embraces. He met Edna on a cold, windy day in May 1931 on a boat returning from Rye Beach. On the deck, she asked him to warm her by kissing her "again and again." Her body was "small and soft and slim." Once when he was selling appliances, a "bewitchingly beautiful" Italian girl answered the door. As his heart thumped, he used his salesman's "persuasive powers" to convince her to let him enter her apartment.

There were also low moments. On a Sunday morning in October 1932, he bragged that a woman he was waiting for in his 2nd Avenue apartment was fonder of him than any he had ever known. When she did not appear, he careened into despair and fury. "Will she never come? Why the hell doesn't she call? I'm hungry. My eyes are tired. On a full stomach I can endure anything. On an empty one I can stand nothing. I hate everything and everybody."

He was most passionate about much older women. The first of these was Sonia, whom he met when he was eighteen. She was twenty-four, a French vaudeville singer with a child, who was separated from her husband. At her home they "hugged and kissed and did everything under the sun but go the limit." Sonia betrayed him with his brother George. At 3:00 a.m. on a November morning, he was despondent. If he could not trust George, he wrote, whom could he trust?

A month later, in December 1927, he was ecstatic about his first cousin, Mary Tolbin, who was eight years his senior and engaged to be married. She was "the most wonderful girl in the world. No man is worthy of her." The two hours he and his brother George spent with her at her home "passed as a minute." At her wedding, he was one of four men who "held the canopy" under which the couple said their vows. Afterward, he kissed her. He swore "to God" that he never had such a thrill as "when she pressed" his hand "during that kiss."

In 1931, when he was twenty-two, he met Drusilla Megee, his first lover and most enduring passion. I discovered by searching the U.S. Census that, when my father met her, she was sixty-one, by far the oldest woman he was attracted to, almost three times his age

and over ten years older than his own mother. She lived on 81st Street, between 2nd and 3rd Avenues, but had been born in Indiana and was the widow of Omar Megee, a physician, twenty years her senior. My father described her in extravagant terms, as controlling his "destiny," and vowed to master Ancient Greek, which she had introduced him to. Mrs. MeGee, as he referred to her in his diary, was, like my mother, musical. She wrote a song, "Oklahoma Memories" (copyright 1932). When she died in the late 1950s, my father was the executor of her will.

When I recorded his stories, I asked if he saw her after marrying. He replied that of course he continued to see her, and added that he "didn't tell Mom" about his "private life." He also explained that Mrs. Megee had helped him overcome his sexual insecurities. I learned more about this from a story he wrote about Sammy Smith, who, though ambitious and driven to succeed, fears he is impotent, a "sexual cripple." He has failed at a brothel and, although sex before marriage is contrary to his own "personal ethics," tried, without success, with a girl he liked. Like Little Billy, who hid his poor vision, he told no one of his problem.

The story relates that, one rainy afternoon when Sammy is selling appliances, Mrs. Morgan, a heavy-set woman in her early sixties, answers the door. She gives him a down payment and invites him to visit her in the evening. When they meet, she remarks that, for women, age is not a barrier in relationships. He asks if she could have anything to do with a younger man like him. She replies that she "relishes his company." Since she is "warm and understanding" and he believes that as a doctor's widow she understands the physicality of sex, he divulges his predicament. Her solution is to have

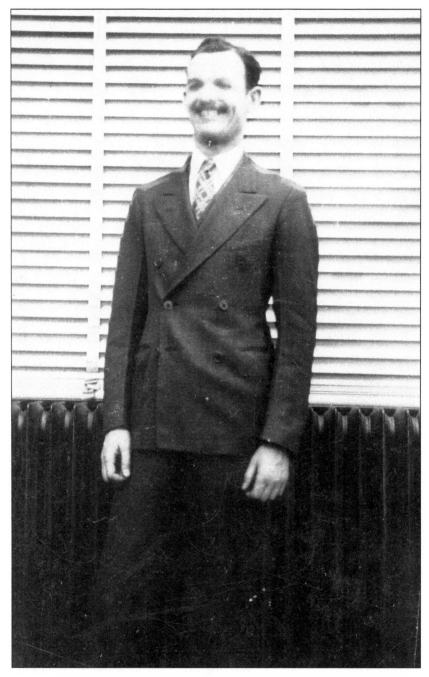

My father, looking as though his troubles are over, about 1930

him sleep with her and wake her if he feels aroused, no matter what time of night. The next day he feels a "new awakening." After several visits, he is certain that his troubles are over.

Rose Morgan was my father's fictional version of both the Mrs. MeGee of his diary and the Indian princess friend whom he would occasionally tell my brothers and me about. As a child and young teenager, I wasn't sure what to make of the princess story; unlike his other tales, it was unrelated to anything or person I knew of. He claimed that the Indian Princess, Drusilla Shyhawk, was related to Chief Black Hawk of the Black Hawk Wars and had a life-long pension because the U.S. government promised Chief Black Hawk that his descendants would never lack income. It didn't occur to me that he and the princess (in the form of Mrs. MeGee) were lovers, but when my brothers and I were adults they told me they had suspected as much.

He also went out with women his own age, but he admitted in his diary that he avoided intimacy with them. On dates he always invited another couple, often his brother George or cousin Julie, and their girlfriends. And he was in no rush to marry. He had refrained from declaring love to Fritzi. In October 1933, at twenty-four, he backed off from a pledge to marry. A girl had proposed marriage to him two weeks before, and he'd agreed. But as they sat on a park bench, he became contrary, and they argued, though, he wrote in his diary, he had no idea why. They parted friends but no longer engaged. This was the outcome he wanted. Calculating his gains and losses, he vowed that he would not "sell" his freedom, "his most precious thing," for a long time, and then "only for real love or money."

Five years later, he married my mother for neither love nor

money, or so he told me, though perhaps this was hindsight. He asserted that he had never loved her. When they met in 1938, he was almost thirty and people were nagging him about getting married. He was drawn to her because she was "very attractive" and came from a "good," cultured family, unlike his "ignorant and illiterate" parents. And he became infatuated when she played the "Moonlight Sonata" on the piano.

In other relationships he retained his freedom by remaining detached or turning on and off emotionally. On one page of his diary he wrote of devotion to his brother George, his cousin Julie, or a friend, Irving, and on another of hate. He idealized a fellow New York Edison employee, Eugene Alban, a German Lutheran, as "perfect, the best looking fellow I know, not conceited, not too independent, but never dependent." He mistrusted others. On a sleepless night in January 1938, just before he met my mother, he wrote several pages to Frieda, a woman from his Lower East Side neighborhood, about his bitter feelings of revenge toward someone he suspected was stealing from him. He never sent the letter.

As I read, I heard echoes of his voice cautioning me when I was a child against dependence. He wrote that he hoped one day to be dependent "on nobody," even to the extent of not allowing anyone to show him "too much kindness." He vowed to avoid sympathizing with others, because this encouraged rather than soothed their "emotional wounds." Even parents should avoid "weakening their children's character" by doing something for them that they could do themselves.

Having learned this lesson of self-reliance, I never asked him for help or money. In June 1978, years after he wrote these words, my

parents sat on a pew in a historic church in Greenwich ?
received a diploma from the New School for Social Res
terward, at the reception in the New School's West 12th S
ing, I introduced my parents to the Sociology Department's Chair.
My father boasted, "She had no help from us —she did it all by her-
self." He seemed prouder of my self-sufficiency than of my Ph.D.

In snapshots from the late 1930s, Bill Turbin appears as a tall,
slim, confident young man in a business suit or a bathing costume
at Coney Island. He no longer wrote in his diary, but I recall stories
he told about his adventures. One year the rabbi father of a friend
hired him to kosher milk for Passover in an Upstate New York town.
When the Gentile family he boarded with asked him why he ate
bacon at breakfast, he lied, claiming that Jews are permitted to eat
pork "if matzo is on the table." The family liked matzo, and he
could be generous at times, so for a few years afterward he sent them
packages of matzo on Passover.

Since the town was near Canada, he decided to hitch a ride from
a passing car so he could cross the border and see another country.
As night approached, he was a few miles from Canada, so, realizing
it was dangerous to hitchhike at night, he thumbed a ride to a train
station and boarded the next northbound train. At the border, the
conductor asked passengers for passports, which were required in
those years. Since my father had none, the conductor instructed him
to disembark at the next stop and board a southbound train. In-
stead he stayed on the train and crossed the border. The conductor
saw him again and shouted at him to get off at the next stop and
take a train back to the U.S. My father demanded to speak to his
supervisor. The conductor retorted that he was in charge and was

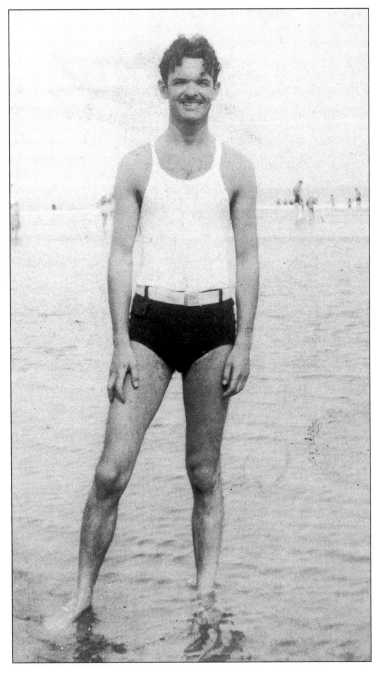

My father as a confident young man, mid 1930s

deporting him. After my father died, I found a letter from the Canadian Immigration office deporting him for trying to immigrate illegally, and his hand-written, unsent reply protesting that he had just wanted to visit. Yet he could be timid as well as rebellious with those in authority, so when our family visited Niagara Falls in the early 1950s, he worried about being on Canada's deportation list. As the rest of us crossed the bridge to Canada, just to say we'd been there, he sat on a bench on the U.S. side.

By the late 1930s, he was no longer a salesman. While he was selling electric irons and toasters door-to-door, New York Edison incorporated as the Consolidated Edison Company of New York, known as Con Edison. About the same time, anti-monopoly legislation passed during the New Deal forced the company to eliminate the appliance business. To compensate for losing his sales job, Con Edison assigned him to dispatch repairmen to deal with gas and electric emergencies. Since he was the sort who lacked sufficient *sitzfleisch* (literally, "sitting flesh,") to sit in one place for any length of time, he fell asleep at his desk, or so he claimed. A sympathetic supervisor assigned him more active work, trouble-shooting. On that job, he liked to claim, he distinguished himself by restoring the electricity at 40 Wall Street, a sixty-story building. He identified an inoperative fuse, which the engineers and electricians had failed to notice.

Finally the company assigned him to meter testing. He ensured that meters accurately measured residents' use of gas and electricity, and searched for and removed illegal "jumper wires," which residents of poor neighborhoods installed to bypass meters and avoid paying utility bills. He chose to work in Harlem because his super-

visors never went there; they feared walking among African Americans. He often said that he had no problem in Harlem, even in the "woist" basements, because "if you treat people like human beings, they treat you that way." And as he said when I listened to his stories, he liked the women. "I slept with more black women than white women."

Though he had a secure salary and medical benefits, his "intense desire" to go "into business" was unfulfilled. He looked for other possibilities because, as he wrote in his diary, if he could "sell for somebody else," he could sell for himself. In the 1930s, he happened upon the dance promotion business. Now he had two jobs, which is how I remember him. On weekdays he was a blue-collar worker for Con Edison, though he proudly wore a business suit to work and changed into a uniform when he checked into headquarters. On weekends, evenings, and hours stolen from his "day" job, he was an entrepreneur. That's a story for another chapter.

In the mid-1940s, the Turbin family's fortunes fell again due— as my father complained—to his brother George's incompetence as a lawyer and his own father's ignorance. George's wife, Martha, worked for a businessman whose son had been indicted for a felony and needed bail money. Since George admired the man's wealth, he persuaded his father to put up the East 4th Street property as collateral. Sam did as his American-born lawyer son asked, but the man's son fled the jurisdiction before the trial. Sam tried to avoid losing the property by transferring the ownership to Martha, probably on George's advice, but eventually the bail bondsman took possession. Then Sam tried to repossess the house by borrowing money to pay the bondsman, but he was unable to keep up the payments.

Except for my father, no one in the family bemoaned the loss of the East 4th Street house. It was the right time to move. During the Depression, when many tenants could not pay rent, Lower East Side buildings deteriorated because landlords refused to pay for maintenance of furnaces and plumbing. As the buildings lost value, Jewish families moved to the Bronx, Brooklyn, and Queens. Sam and Pauline's new apartment, on the corner of Second Avenue and East 9th Street, was affordable; their costs were low, since the apartment was rent-controlled and they let one of the three bedrooms to a boarder. And it was a step up in life. The seven-story elevator building was on a prestigious avenue, close to the vibrant Yiddish theater district and Ratner's kosher dairy restaurant.

My father sometimes took me to visit this apartment on one of our many trips to Manhattan. At home he was volatile, but at these times he was calm and attentive. We took the Long Island Railroad (LIRR) station a few blocks from our house. I felt special as I sat beside him on a scratchy rattan seat, dressed in my best toe-pinching shoes; when the train entered a dark, scary tunnel, I knew we were approaching Penn Station. He guided me through subway turnstiles, up and down concrete stairs, through white-tiled tunnels, and across streets teeming with people and rumbling with cars and trucks.

I anticipated these excursions with tingling pleasure and gave no thought to why my mother and brothers weren't with us. I'm sure my father didn't ask her to accompany us, but had he done so I doubt she would have agreed. She complained that Pauline was illiterate and ignorant of birth control, having had seven children, and that she haggled at pushcarts. My mother shopped only at elegant department stores and told me not to say "Oy, vey" because

that was the language of old ladies.

The elevator ride in my grandparents' building was thrilling. My father opened the clattering black iron gates, and my heart raced as we slowly rose and shuddered to a stop. In a dark hallway he rang a doorbell, and Grandma let us into rooms with wood furniture and sunlight from windows facing East 9th Street. My grandmother had iron-gray hair fastened at her neck and wore a loose cotton dress; she served a "gless tea" with a long-handled metal spoon, which my father said absorbed heat to prevent the glass from breaking. Later, at Ratner's, he ordered lunch; I loved the pickled green tomatoes. Seated across from him, I felt intensely alive.

I was touched that my father, retelling his stories in 2004, recalled the afternoon when he took me to the Bowery factory that manufactured his souvenirs. I struggled to keep up with his long stride as we walked beneath the Third Avenue El, now long gone. At the doorway of a low brick building, he stepped over a drunken man resting against the doorframe, and I, trustingly, followed his tall figure up steep, dimly lit stairs to a loft with high sooty windows. He showed me fascinating iron wheels, metal tubs with faucets, and clay models ready to be cast and plated in bronze. Their shapes were familiar— stately horses, the Empire State Building, and the Statute of Liberty.

Sometimes he took me to shops that sold his souvenirs. In Times Square he showed me a flea circus, tiny insects in miniscule finery jumping through hoops. On my birthday he took me to the Ringling Brothers' Barnum and Bailey Circus at the old Madison Square Garden. On Thanksgiving we went to the Macy's parade and watched an enormous Mickey Mouse balloon sway in the wind. My brothers

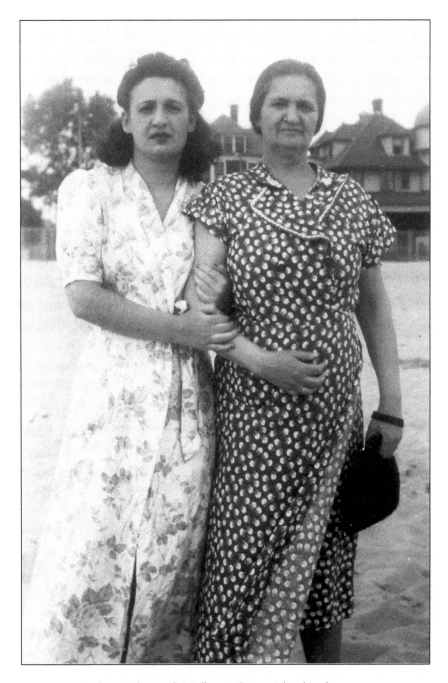

Pauline Turbin with Mollye at Coney Island in the 1950s

stayed at home with my mother, who prepared dinner for Aunt Lil, her older sister, her husband Uncle Sam, and my cousins Bob, Barbara, and David, who lived near Bridgeport, Connecticut. As we walked home from the LIRR station, my father carried me on his shoulders singing,

Show me the way to go home.
I'm tired and I want to go to bed.
I had a little drink about an hour ago
and it went right to my head.

When the U.S. entered World War II, many Jewish men were eager to fight Nazis, but not my father. He was determined not to serve. He must have known that he was unlikely to be drafted. In 1940 he had been classified as "3", because he was older (thirty-one) and married; serving would be a hardship for his dependents. Despite this, he took another step to avoid being a soldier. He knew that men with mental problems were ineligible for service, and that the armed services considered stuttering a psychological affliction. So he obtained a letter from a psychiatrist, the head of the National Hospital for Speech Defects, certifying that he stuttered.

Toward the end of the war, he would not have expected to hear from his draft board, as he was then thirty-five and had more dependents, not only a wife but also a child (me) and another on the way (my twin brothers). Yet in 1944 the U.S. military was desperate for fresh troops, so older, married men with children were reclassified "1A", eligible to be called up. Still, he didn't have to use his letter. Before his draft board notified him to appear in person, the war

ended, in Europe in May and in Japan in August 1945.

From time to time my father offered excuses for not having served in the conflict that shaped his generation. When I was a child, he claimed he was exempt because he worked for an essential utility or—closer to the truth—was too young for the first war and too old for the second. When he was about seventy, he said he didn't want to fight in the war because he could never shoot anyone. One day in 2005, when he was ninety-five, recovering from surgery for a broken hip, he came out with the bare truth. Musing about the reason for the accident that broke his hip, as he often did about the cause-and-effect of even minor health problems—colds, indigestion—he said that it was his punishment for avoiding service in the war. "Dad," I said, "I thought you said didn't want to serve because you could never shoot anyone."

"Nah, that wasn't it. I couldn't be a soldier—I could never follow orders."

As I was writing this sentence, I thought about how aware he was at ninety-five of his self-serving, egocentric motives. And he unapologetically admitted them to me, his sixty-three-year- old daughter. No, he was not a phony.

My mother, 19, in 1934

3.

Ruth

PEOPLE SOMETIMES SAID I WAS FORTUNATE to have such a sweet, beautiful, talented mother. Aunt Marian, my father's younger sister, once remarked admiringly that my mother never raised her voice in anger, even when my father was at his most self-centered and enraged. I do remember sweet, tender moments, when she would read my favorite book out loud, sing "Frère Jacques," or repeat her mother's French: "*Quelle heure est-il?*" I loved to watch her play the piano; her body swayed gently to the music, and her fingers danced across the keys.

But I mostly recall her as restrained and emotionally absent, even when she was physically present. Her eyes rarely met mine. Tall, with black hair in a bun, she would speak to me in low, even tones as she washed dishes, kept an eye on a pot on the stove, or ironed a blouse. When I sat on a stool beside her at a Woolworth's lunch counter after shopping at a department store, she would gaze at the

soda she sipped. Yet she seemed to observe everything about me. Often she would comment on my appearance, my unruly hair, dirty fingernails, a blouse not tucked into my skirt, or a sock fallen about my ankle. When I practiced the piano, I would hear her call from the kitchen, "That's F sharp, not F flat" or "It should be three-quarter time." She had perfect pitch, and I did not.

She often let me know that she had married beneath her. Ida Kantor, her grandmother, who nursed me through measles when I was six years old, was born Idarose Schoor in 1874, the daughter of Samuel and Eva Luxemberg Schoor, prosperous textile mill owners in Lublin, Russian Poland. At age seventeen, which my mother said was late in life, Idarose married Benjamin Braun. The same year, on August 20, 1891, she gave birth to a daughter, my grandmother Eva, whom Idarose named after her deceased mother. Soon afterward, Ben left his wife and child to seek his fortune in the Australian Gold Rush. I suspect that Idarose and Ben had had an affair, she'd become pregnant, and her parents, or perhaps her father—her mother had died or was dying—had insisted they marry. When Ben went to a far-off land, she was left in Lublin with a less than respectable reputation, no husband, and a baby, with no mother to help her. My mother once said that Ida had traveled with Eva to other European cities, perhaps Jewish settlements in Germany or France, and had liaisons with other men, but there are no records of those years.

According to an immigration form issued by the Préfecture de Police, Idarose, twenty-five, and Eva, eight, arrived in Paris on August 26, 1899. Three weeks later, a French official registered Eva and her mother, who called herself "Rosa," as "*Étrangers.*" They

lived at 21, rue Charlemagne, near the corner of rue du Figuier, and later on rue de l'Hôtel de Ville. Both streets were in the Pletzl (Yiddish for "Little Square") in the 4e Arrondissement. This was the home of most of Paris' Eastern European Jews; many were leftists who frequented left-wing cafés, a library, bookstores, and discussion forums. After a few years, Ben Braun returned to Europe but not to his wife and child. He settled in London and, according to family lore, ran a pub, remarried, and lived upstairs. He and Idarose must have divorced, either before he went to Australia or afterward. Yet he kept in touch with Eva, who at least once crossed the Channel to visit and learned some English.

I knew little about Rosa's and Eva's Paris years until after my father died. He had saved, not only his own correspondence, but also a letter to my mother from her older sister Lil. Lil described, in a matter-of-fact tone, a life that must have been hard for young Eva and for Rosa, who had been born into a prosperous household with at least one servant. Mother and daughter lived in one room and slept on a mattress on the floor. Since the toilets and water pump were in a rear courtyard, to bathe and cook they had to carry heavy pails of cold water up narrow, winding stairs, and heat the water on a wood-burning stove. Rosa supported herself and Eva as a "casquettière," a cap maker who sewed at home, one of the few respectable occupations available to young immigrant women in Paris. She was paid by the piece by a shop-owner in nearby rue Aubriot and earned nothing during the off-season when there was no work.

Yet for Polish Jews, Paris was a haven of equality and opportunity. Anti-Semitism was at a high point, due to the Dreyfus affair (in which a Jewish army officer was accused of treason), but it did

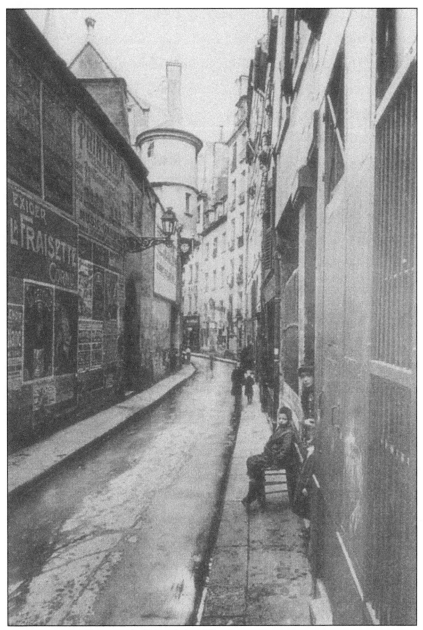

The rue de l'Hôtel de Ville, Paris, France, in 1900,
where Eva and Nathan lived next door to each other.

not take the form of pogroms as it had in Poland in the 1880s. And unlike Poland, where public schools required Catholic religious worship, Eva had a free secular education at a girls' school on the Place des Vosges. At ten and twelve she won awards for reading, writing, drawing, dressmaking, hard work, and "bonne conduite." Her prizes were two volumes on educational topics with faux leather covers, the seal of Paris, and the words, *République Française, Liberté-Égalité-Fraternité*, printed in gold.

In 1911, Eva married Nathan Fiedler, a house painter. Since I knew my mother disdained my father's Lower East Side roots, and that Eva's family was wealthy compared to Nathan's, I asked if Grandma Eva had married down. No, she replied, Grandpa was very handsome and very smart. I remember him as tall, robust, and usually clad in a suit, white shirt, tie, and steel-rimmed eyeglasses that gave him a dignified look despite tiny droplets of paint on the lenses.

When we visited him and Eva in their Bronx apartment, he talked about his life as he cooked and served steaming chicken stew or beet borscht. He would claim that he had been "chief cook" in the Russian army. I assumed he embellished this tale, because of the mischievous gleam in his eye and my mother's warning that he sent letters describing fabricated domestic woes to the Forward's "*Bintel Brief*," a column offering advice to troubled readers. The editor published a few, not knowing that the stories were concocted. When Nathan told me where he was born on July 10, 1881, he always spelled out the city's name in the English alphabet, L-O-D-Z. As an adult I realized he did this because he had no love for Christian Poles and rejected the Polish alphabet and pronunciation, which in English

sounds like "Woodge."

Nathan had a way of summing up situations in pithy phrases tinged with sarcasm. He was "a painter, not a 'shmeerer.'" His father was "a tailor who forgot to knot the end of the thread," so I pictured him poorly dressed, bent over a garment, and pulling a thread through the same spot over and over. In a photograph taken in Lodz about 1910, the father, Hersh, does appear muddled. He is tall, slim, and stooped, in a caftan and cap with a visor, which were typical of Russian peasants and workers; he sits beside his wife, his hands on his knees as if he does not know what do with them. Beside him, Beatrice is also tall but large-boned and confident, with a hand on his shoulder. She wears a gold chain, locket, and wig, the mark of a religious Jew, like her husband's full beard.

I knew nothing about the difficulties Nathan had faced until I did research for this memoir. He was probably forced into the Russian army at sixteen and served as a cook for the soldiers. Wealthy Jewish families purchased exemptions from the army—Jews were mistreated and had to serve longer than Gentiles—but Nathan's family was poor. After leaving for the army, Nathan probably never saw his parents again, though they corresponded and exchanged photographs. I don't know how long he served, but I know he escaped and fled to Paris. Typically, deserters like him traveled by foot and sneaked across the Russian border to safety in Germany. Once in Western Europe, where borders were relatively open, they made their way to France and followed train tracks to the Gare du Nord. Along the way they were assisted by a Jewish aid society or the Bund, a Russian Jewish socialist organization, of which Nathan was an active member.

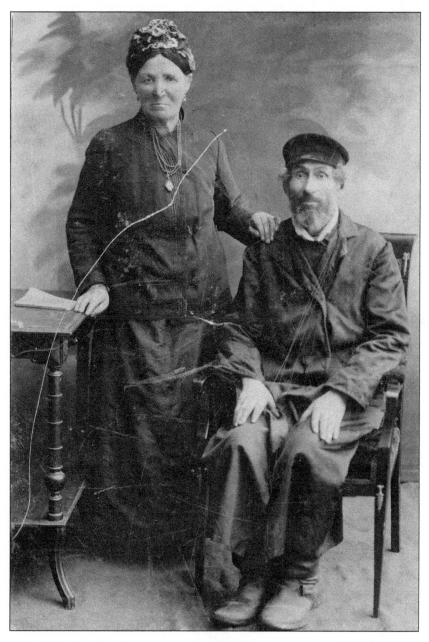

Beatrice and Hersh Fiedler, between 1910 and 1915

He probably arrived in Paris in 1900 at nineteen, exhausted, dirty, and hungry. According to Lil's letter, he worked as a house painter and boarded with Jewish families on Boulevard Arago, Rue des Rosiers, or Boulevard Sebastopol. Later he shared a flat with other young men who, as Socialists, called their residence a "commune." Sometimes they didn't have enough money for food, so they stole freshly made bread, which bakers set out in the front of their shop to cool.

He once told me that he first noticed Eva in 1902, when he was twenty-two and she was a child, as he put it, too young for a romantic relationship. He probably saw her, a pretty, round-faced schoolgirl of twelve, walking on rue de l'Hôtel de Ville; he lived at no. 20, and she and her mother resided in the next building. Three years later, Nathan's uncle, Abraham Rosencrantz (probably his mother's brother, who lived on Essex Street on the Lower East Side) paid for his second-class passage to New York. On December 30, 1905, Nathan sailed from Le Havre on the *SS Gascogne*; he disembarked on January 9, 1906.

Idarose and Eva probably reached New York about 1908, when Eva was seventeen. In 1910 Eva boarded with Jack and Adele Hadel on East 4th Street, a few blocks west of the street where my father lived two decades later. Her mother, now Mrs. Kantor, lived with her new husband. Eva worked as a hat-maker—or as my mother would proudly say, a "milliner." Once she showed me a floppy blue felt hat, which she said Eva would place on a head-shaped form, soften with steam, reshape, and adorn with ribbons, silk flowers, or feathers. About that time, Nathan met Eva again, probably through the Workman's Circle, the U.S. equivalent of the European Bund.

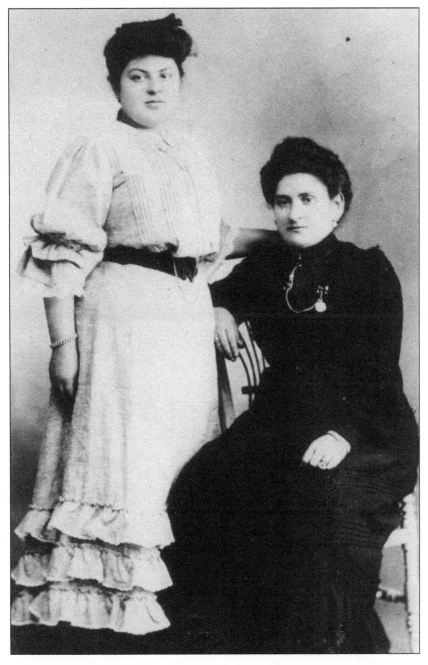

Eva Braun Fiedler, 19, and Ida Schoor Kantor, 36, in 1910

He told me he was impressed that she was already fluent in English. In 1910 they became U.S. citizens and married in 1911, when he was thirty and she was twenty.

In photographs taken about that time, Nathan and Eva are well-

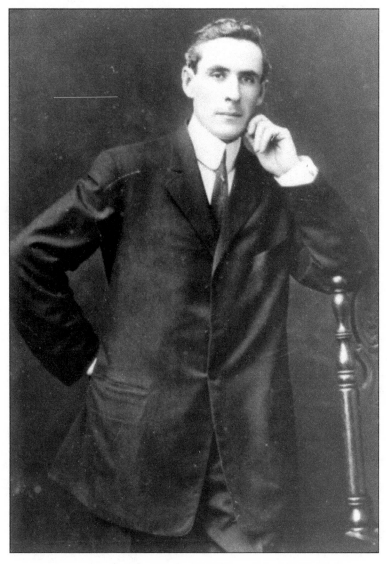

Nathan, 31, in 1915

dressed young adults. Nathan has broken with his parents' religious observance. He has his mother's high cheekbones and stern expression, and is clean-shaven, hatless, and clad in a suit with a fashionable three-button jacket. Eva appears restrained but sweet, pretty, and elegant, much as my mother would be when she was young, in a long ruffled dress with a belt encircling her waist. Ida, seated beside her, has a formidable expression; a gold watch and chain stand out against her somber black dress. According to my mother, Nathan often exchanged sarcasms with his mother-in-law, who was only seven years his senior; he warned my mother not to marry someone whose mother was close to her own age.

When my mother was born, March 13, 1915, they lived on Tiffany Street in the South Bronx. Lillian had come into the world in December 1912, and Harold followed in January 1919. In a snapshot taken on the roof of their building, Nathan, about thirty-seven, clad in a suit and white collar, holds his daughters affectionately. It was probably about this time, when immigration had opened up after World War I, that Nathan sent his parents money so they could travel to the U.S. My mother said they died before they could get here; perhaps they were among the millions who died in the worldwide 1918–19 influenza epidemic.

He probably did bring his younger sister, my mother's Tante Pauline, to America. My mother described her as an unmarried housekeeper for a wealthy, observant Jewish family. I remember her vivid presence on one of our visits to our house. As she greeted me in Yiddish-accented but clearly enunciated English, I smelled perfume and her rouged high cheekbones. She wore a burgundy dress with a full, calf-length skirt and frills at the collar and cuffs; her red-

Nathan with Ruth (left) and Lillian (right), about 1919

dish-brown hair, with gray at the roots, was piled high on her he
She gave me a wet kiss on the cheek and a chocolate bunny. It must
have been Easter Sunday.

About 1920, Nathan and Eva moved their young family to Pas-
saic, New Jersey. Many of their neighbors were also from Lodz,
which like Passaic and nearby Paterson was a major textile-produc-
ing center. Since Nathan aspired to be a businessman who wore a
suit when he worked, not a manual worker in paint-splattered cloth-
ing, he opened a dry goods store, which sold undergarments, bed
linen, and basic clothing. They lived in an apartment above the
store, where my mother and Lil worked after school. At home they
spoke English, but the children learned Polish phrases, Yiddish, and
some French. In cold weather they all wore woolen underwear in-
doors; heat from the coal stove was insufficient. They had only a
few sets of clothes, which they hung on hooks on a closet wall, not
hangers on a pole. Illness must have been a worry. One winter my
mother and Eva had diphtheria; they were driven in a horse-drawn
vehicle to a hospital and recovered in the same room.

My mother often told me that, as a child, she had felt lonely be-
cause she and her family were outsiders, the only secular, cultured
Jews in a neighborhood of Orthodox Jews and Polish Catholics.
Eva advocated Woman Suffrage and studied Esperanto, which in-
corporates words from Romance languages. Both parents listened
to classical music, read poetry and philosophy, and, as Socialists, ran
unsuccessfully for local office in 1925. Eva was one of three women
on the ballot and the only woman among twenty-five left-wing nom-
inees. My mother recalled Harold, a talented artist, drawing pictures
in chalk on the sidewalk outside the store. Harold remembered the

sounds of my mother practicing the piano, playing pieces over and over.

She must have yearned for a more American life, for that is what she wrote about in stories and poems, some published in a local newspaper. She often read aloud to my brothers and me from a slim volume bound in brown cloth with orange endpapers, which she had created for a school project. Her characters had English names: Mrs. Simpson, Mr. Carter, Ellen Clarke. Little girls hunted for decorated eggs on Easter Sunday and anticipated Santa Claus' appearance in the fireplace on Christmas Eve. The heroine of a rhyming ballad, "Margery, Peter, Dick and I," is imprisoned by a dragon with a "fiery tail" and rescued by a "a brave bold knight" in a "suit of shining mail." In the end, they marry.

She once told me, emphatically, that when her family returned to

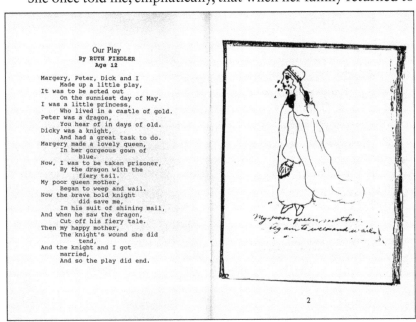

My mother's play

the Bronx in 1928, they rented a small, more expensive apartment rather than a larger, cheaper one on the Lower East Side, "where the poor, uneducated Jews lived." Nathan's store had failed due to a divisive, region-wide textile strike during which unemployed workers could not afford to buy his goods. Their fifth-floor walk-up on Mapes Avenue had central heating and hot water, unlike their Passaic home, but it was small for a family of five. Eva and Nathan slept on the living room sofa, which opened into a bed. Nathan returned to house painting and began a contracting business, Columbus Properties. Ruth took music lessons from a concert pianist, Sara Sokolsky-Fried. On a Sunday afternoon in June 1929, when she was fourteen, she played Sinding's "Rustles of Spring" and Mendelssohn's "*Rondo Capriccioso*" at a recital at Steinway Concert Hall on West 57th Street.

My mother sometimes took my brothers and me to visit my grandparents' Bronx apartment on weekends. My father never accompanied us. I learned from hints, and my father's absences on these excursions, that my mother's parents shared her disdain for him, and the feeling was mutual. My father confirmed this when he was ninety-two. He, Bill Turbin, was a businessman, "and what was Nathan? A house painter."

Eva and Nathan's apartment seemed far away because, to get there from where we lived in Queens, we took two buses and crossed the Whitestone Bridge. I always sat by a window, so I could see the expanse of Flushing Bay and distant Manhattan skyline. The bus stopped on a treeless road near 181st Street, a few blocks from the zoo. We climbed stone stairs to the apartment and entered a long, narrow hall leading to the living room. The glass-topped coffee table

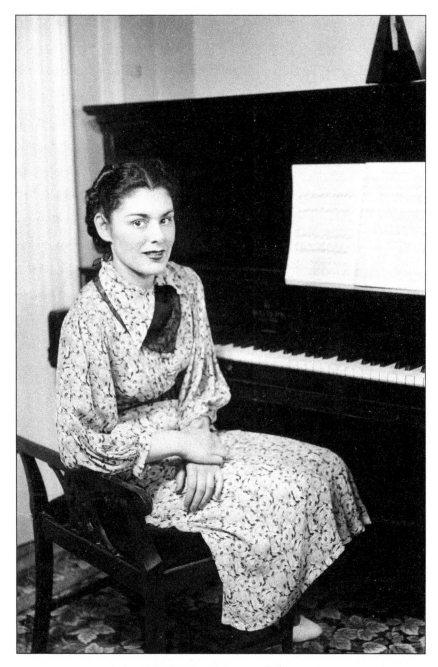

An invitation to a piano recital in 1936

was always strewn with what seemed to me exotic objects, such as a set of dominoes and records in brown paper sleeves.

Nathan considered himself an artist of sorts. There was little daylight in the kitchen and living room because the windows looked out onto an air shaft, so he brightened the rooms with color. He had painted the kitchen floor linoleum deep blue, the shelves above the double sink red, and the cast-iron stove's curved legs yellow. Once, when we visited him in the 1950s, after Eva died, he delightedly showed us how he had transformed the living room. He painted the walls a fashionable deep burgundy and papered one with a cabbage rose design in the same hue. About the same time, when I was ten or eleven, he attended a party at the private art class my mother had enrolled me in. I had won a prize for a pastel still life. After the award ceremony, he asked me with his usual twinkle, "Did you tell your art teacher that your grandfather is also a painter?"

My mother often told me, pensively, that Nathan had been unemployed during the Depression because he had tuberculosis. As a child I often peered at snapshots in my mother's album. But since I knew my grandfather as strong and robust, I didn't recognize him in the picture of a tall, frail, hollow-cheeked man leaning on a cane in front of the porch of a frame building, probably the tuberculosis sanitarium run by the Workman's Circle in Liberty, New York. My mother said that, while Nathan was in the sanitarium, Eva had earned money by working in a milliner's shop, and she herself had been forced to quit high school and go to work. Since the family couldn't afford her piano lessons, her teacher had given her a scholarship. She was seventeen, the same age as Idarose when she married and gave birth to Eva in Lublin, and about the same age as Eva

Nathan at a tuberculosis sanitarium in the 1930s

when she arrived in the U.S. Lil, about twenty, was soon to be married, and Harold was thirteen.

My mother's first job was sorting buttons by size and color in a factory. This was a lucky break; during the Depression most employers preferred to hire men, who had to support a wife and children. Soon she found more prestigious work filing in an office and, to advance further, studied stenography. Once she showed me her notebook, filled with rows of squiggly pencil marks. When her employer found her studying a steno book during lunch hour, he fired her. Why pay a girl who did not intend to stay on the job?

She often told me that, one day, Eva had taken her aside in the bathroom, just off the long hall to the living room, and given her money to learn to be a model. Nathan had ordered her to spend only on essentials, but Eva had secreted this cash from her household fund. Eva understood fashion. In a photograph from about 1915, she posed in the manner of a Gibson Girl, leaning slightly forward, corseted with a belted waist, like Charles Dana Gibson's drawings in newspapers and magazines in the 1900s of ideal young, educated women, clad in a shirtwaist and skirt, with "S curve posture." She knew that her daughter, who had movie-star looks, could be more than a secretary. Ruth was slim yet full-figured, tall for her generation—five feet six—with abundant black hair, high cheekbones, and a sensuous mouth.

After training, my mother posed in bathrobes for a garment district factory. Later, when she took me shopping at Altman's and Saks Fifth Avenue, she said, wistfully, that in those days she couldn't afford even mid-priced Macy's and Gimbel's. So she bought dresses from the five-dollar, and later the ten-dollar, rack in the bargain base-

Eva Braun Fiedler, 21, in 1912

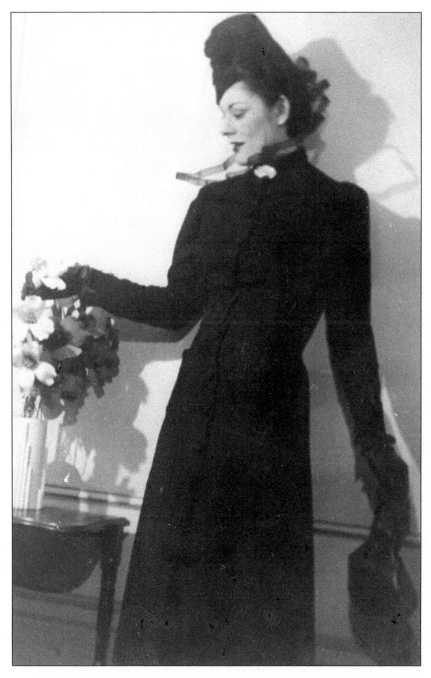

My mother in a professional fashion photograph in 1937

ments at Stern's on 42nd Street and S. Klein at Union Square.

She told me that Nathan wanted his son go to college and become a dentist, a professional, but Harold intended to be an artist. In those years, a college degree was unnecessary for an art career, but he went to CCNY as his parents wished, though so reluctantly that he was often late to class. My mother, who regretted not going to college and never took taxis, said that Eva gave him cab fare, which they could ill afford. She said Harold told his parents he was graduating with his class, though he never received a degree. They attended the ceremony, but CCNY's Lewisohn Stadium was too massive for them to identify individuals on the stage, and there were too many graduates to call out each name. Later he became a successful commercial artist, specializing in calligraphy and devising typeface designs or fonts. One, Fiedler Gothic, is still available commercially.

When I was five or six, Harold lived with Nathan and Eva, and on visits he would invite me to his bedroom/art studio and draw while I watched. Once, as I sat on the floor beside him, he dipped a brush in watercolor and created an image of children seated on the bars of a jungle gym. I don't recall that he said anything to encourage me to be an artist, but then he said little to anyone. He was handsome, with an arty brush moustache, but had a shy, awkward manner. According to my mother and Aunt Lil, his uneasiness with people was due to having been shell-shocked in the war.

I knew little about Eva's illness and death. She was fifty-nine then, I was not quite nine, and my mother was thirty-six. In those years people were secretive about cancer, and women didn't discuss female bodily functions with children. When I was older, my mother

explained that Eva, a modern woman, had taken pills to relieve menopausal symptoms. But doctors were unaware that estrogen could cause cancer if it was not taken monthly with progesterone to slough off the uterine lining. And the Fiedlers didn't know that frequent urination was a symptom of a tumor pressing on the bladder.

The Fiedlers preferred their other son-in-law, Sam Geneslaw, who married Lil in February 1933. Sam was the son of a Paterson, New Jersey, silk weaver from Lodz and a Socialist and union man, like Nathan, a Bundist and member of the Brotherhood of Painters, Decorators and Paperhangers. At first Sam was an organizer for the International Ladies Garment Worker's Union (ILGWU) in Connecticut. Since many of the workers were Polish Catholics, he changed his surname to the ethnically neutral Janis. In the early 1960s he was promoted to vice president of the union's mid-west region and moved to Cleveland.

Sam had a deep, gravelly voice and peppered his conversation with accounts of labor struggles, jokes, and family stories. He delighted in recounting Nathan's warning to him when he married Lil: "I have two daughters, Ever-ready and Never-ready. You are marrying Never-ready." Lil was serious, a member of the Young People's Socialist League, and always at least an hour late. Ruth was punctual, reserved, and loved a good time. According to family lore, Lil met Sam on a picket line. Ruth met Bill Turbin at a dance.

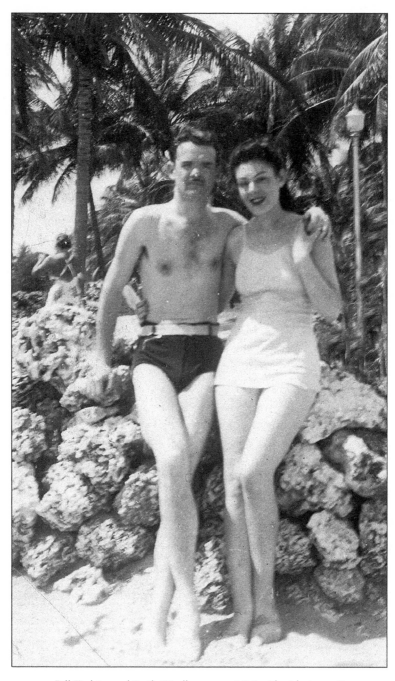

Bill Turbin and Ruth Fiedler on a visit to Florida in 1938

4.

Danceens

I LIKE TO IMAGINE HOW MY PARENTS MET. On a Saturday evening in 1938, Bill Turbin noticed a strikingly attractive young woman at a social he had promoted and invited her to dance. Ruth Fiedler enjoyed the attentions of the tall, slim social director with black hair and intense eyes, who was obviously experienced with women. Their courtship took them as far away as Florida. In a snapshot, they are a glamorous couple clad in bathing suits in the sun-drenched tropics, shaded by palm trees. Ruth has an easy smile and graceful bearing. Bill, with the thin moustache he grew to appear older and kept almost to his dying day, looks pensive. They married on March 19, 1939, at the Hotel Hamilton on West 73rd Street. Both were older than most people of their generation were at their weddings. He was almost thirty, and she was just twenty-four.

This was the Swing Era, roughly 1937 to 1945. While Black au-

nces danced the Lindy Hop to jazz in Harlem, whites at down-
vn clubs and ballrooms enjoyed the sedate music of orchestras
with twelve to sixteen musicians. Swing adapted the exciting beat
and tempo of jazz, which was rooted in improvisation, to popular
songs with standard words and music. The rhythm was ideal for
dances like the foxtrot, which were based on regulated steps, like
the older waltz, but were slower with more intimacy. Fox-trotting
couples danced "cheek to cheek."

In February 1943 an article entitled "Danceen: A New Word for
a Good Idea, Invented by Bill Turbin" appeared in Con Edison's em-
ployee newsletter, Around the System. The subject was a dance Bill
Turbin had organized for his union, Local 1-2 of the Brotherhood
of Consolidated Edison Employees, on Friday evening, November
6, 1942, about seven months after I was born. The benefit, to raise
money for servicemen, was held at the Hotel Governor Clinton, on
West 31st Street, with music by Buddy Kaye and his orchestra. A
circular urged, Let's get together for the good of the boys and have
a swell time.

Bill Turbin had gotten into the dance business in the mid-1930s,
when he belonged to the Yosian Club, founded in 1922 by J. Otis
Swift, a naturalist. Since he enjoyed the club's weekend country
walks, he had the idea of weekday evening social occasions. He
"borrowed a studio, phonograph and records," mimeographed a let-
ter, and became "a promoter of a successful party." As the events
grew popular, celebrities such as Moe Leff, the cartoonist, and Pat
Rooney, a singing and dancing comedian, dropped by to greet the
crowd, entertain, or give a talk. There were "more peaceful ways to
spend an evening than" chairing "a dance committee," but "Turbin

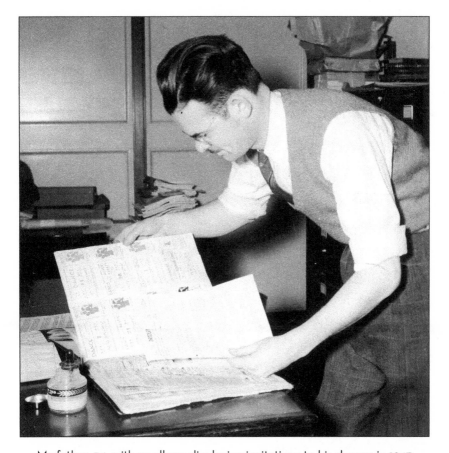

My father, 34, with an album displaying invitations to his dances in 1943

never heard of them." He enjoyed himself, "meeting lots of interesting people who were having the time of their lives."

I imagine him at his charming best at these dances, greeting people with a grin and entertaining them with jokes or stories. For Ruth Fiedler, these events—which promised an innocent, romantic evening for a modest fee in school halls, social clubs, or midtown hotel ballrooms—were preferable to smaller dance socials run by saloon proprietors who profited from liquor sales. These socials often involved excessive drinking and inappropriate sexuality. Bill Turbin's "All

Welcome Club" dances were held at The Club House on West 85th Street, between Columbus and Amsterdam Avenues. "Get Acquainted Club" events took place at Steinway Hall on West 57th Street, where my mother had played in her teacher's piano recital in 1929.

Bill often claimed to be unmusical, but he must have had a good enough ear to hire musicians for his dances. He could play "Home Sweet Home" on the piano and loved to hear my mother play. Most of the bands were relatively unknown—Jack Blue and His Juvenile Stars of Tomorrow, A Latin Rumba Band—but a few were "names," such as Buddy Kaye and Cab Calloway.

His business strategy was to identify himself as social director in order to give the impression that the sponsor was a social club, not an entrepreneur. He negotiated a low rental price from clubs and charged twenty cents before 9:00 p.m., because later in the evening people would pay forty cents to join a crowd enjoying themselves. And he wrote his own copy for flyers, which featured stylized images of dancing couples, and newspaper ads in the Daily Worker, the New York Post, and the East Side News.

With typical hyperbole, he promised balloon dances, Conga Lines, "College Capers," contests, and door prizes—"Fun. Frolic. Frivolity." "Yes, it's true. Five solid hours chock full of FUN and FROLIC for only a quarter." Once he circulated a newsletter entitled "The Chimney: The Friendship Builders Hot Air Outlet," with a column called "Tin 'Pun' Alley." One quip was, "Don't open a barber shop, there's too much cutthroat competition." Another ad enticed people to "Dance to the rhythmic strains of Artie Trent and his Orchestra":

An evening of joy, an evening of gladness,
That will cheer your heart and smite away sadness.
Dancing and fun to send gloom on the run,
Friends there are many, foes there are none.

The dance where he met my mother was a Saturday Friendship Builders' social at the Rand School of Social Science on East 15th Street near 5th Avenue. To my mother's Socialist parents, the school, run by the Social Democratic Federation, was suitable for meeting young men. The six-story building, known as the "People's House,"

The Rand School auditorium in 1938. The chairs were removed for dances.

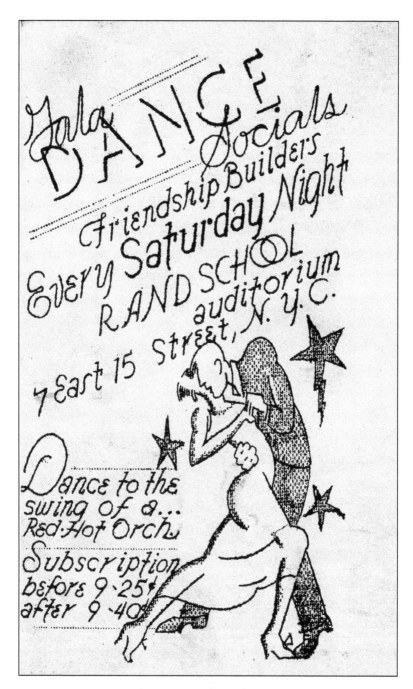

Advertisement for Gala Dance

offered courses in contemporary topics, academic subjects, and socialist theory. For my father, who would have known about it from his left-wing siblings, it was a convenient downtown auditorium accommodating "500 fun-loving guests." "Never a dull moment from 8:30 to 1 AM."

Soon he aimed higher. The dazzling ballrooms of the Hotel Governor Clinton and the Diplomat, near Times Square, had crystal chandeliers, high arched ceilings, plush drapery, and polished oak floors. He added new features, such as "Dance Stylists" who encouraged people to try new dances by teaching them more elaborate

Advertisements for dances at hotels

steps. A Saturday Social at the Diplomat, on December 7, 1940, offered "Free Hawaiian Leis." A moonlight social on a boat departing Battery Park at 8:30 p.m. cost seventy-five cents round-trip. Twelve dollars purchased a Fourth of July Weekend at the Kiamesha Overlook Hotel, in Monticello, New York.

Bill Turbin came up with the idea of Danceens in 1941, when the U.S. entered World War II. According to the Con Edison newsletter, he had observed that, in New York, many of the millions of soldiers, sailors, and marines who arrived by train and ship en route to the Pacific or Europe were crowded out of canteens run by the United Services Organization (USO). These, and the American Theatre Wing's Stage Door Canteen at the Hotel Diplomat, were modeled on canteens at military bases and overseas, which provided servicemen with meals and entertainment, often music and comedy routines.

My father decided to create something similar to accommodate the overflow. First he formed the United Nations' Club, based at the Nola Studios, at Broadway and 51st Street, which he advertised as welcoming United Nations Servicemen—soldiers from the Allied nations. Later, he promoted Danceens on Wednesday and Friday evenings, starting at 7:00 p.m., in a hall on 7th Avenue near 54th Street. A letter from the New York City Defense Recreation Committee, Inc., dated June 11, 1943, commended him as "one of those who helped" to guide the "nearly eleven million men" in the "Armed Services of the United States and Allied Nations on leave in the City" to "good times" or services that they needed. Letters from servicemen and families testified that people all over the U.S. realized that "'New York is a Friendly Town.'"

Bill Turbin's Danceens, unlike canteens, were businesses, which he calculated would be more profitable if he maintained a wartime spirit. He advertised that, for servicemen, the fee was "Your Uniform," the "Tax—Your Smile." He did not advertise the charge for checking hats, which was his way of turning a profit. In an era when all adult men wore hats, they were essential to military uniforms; it was good manners to remove them indoors. Sheer volume made up for the low fee, and expenses were low. At Danceens, couples swayed to recorded music, usually a movie sound track, not a live band, and entertainers volunteered their services.

Invitations to Danceens were sober calls to young women to contribute to the war effort. No more enticements to fun and frolic. A letter on formal stationery exclaimed that there were "far too few places for the free entertainment of lonesome Service Men in New York." It urged those interested in "bringing happiness" to men who risked their lives to "preserve your way of life" to "apply for a Receptionist Certificate." Another way to help was to contribute used records to be resold to raise money for the war cause. Young "ladies" who "register as hostesses" should regard the Danceens as "their group and their work" and should not "hesitate" to "make suggestions for improvement."

Danceens were more boisterous than club socials, where adult men and women paid for amusement after a workday. At Danceens there were often twice as many men as women, and most men were eighteen or nineteen, far from home, unfamiliar with big cities, and anxious about serving in the war. To maintain order, my father issued rules. Since women ("hostesses") were admitted free, he had to ensure that they were not prostitutes seeking business. Before

being admitted, a woman had to fill out a form with her name, height, weight, age, occupation, employer, and character references. She had to "act like a lady"—not chew gum, talk loudly, or whistle. She must approach men who were shy and not refuse to dance with a man unless he was drunk or "unmannerly." A woman could not "remain with one man all evening" or "leave with a man" early. To

My father with an unidentified woman at a Danceen in the early 1940s

ensure that enough women attended, they had to attend at least one dance weekly and arrive before 9:00 p.m. If a woman missed a dance for more than three weeks in a row, he canceled her registration.

To encourage mingling, he organized "mixers." On a frayed notebook page, he penciled the title of one type of mixer, "Paul Jones," and detailed eleven steps. A line of women face a line of men. Each man walks up to the woman opposite, bows, and introduces himself. A whistle blows, music begins, and pairs of men and women march about the room. Another whistle. The music stops and new lines form. Again, men and women march about the room and then stop. Each woman introduces herself to the man standing opposite her.

In October 1942, he aimed higher, for the *crème de la crème* of hotels. The Astor, on Broadway between 44th and 45th Streets, featured eighteenth-century French period-style ballrooms with crystal chandeliers and gold-trimmed white ceilings. A sales and promotion director offered him a ballroom on Saturday, October 24, 1942, at a low fee, on condition that he donate some proceeds to U.S. Coast Guard canteens, which were similar to those for servicemen. These were popular in coastal cities like New York, where many people wanted additional coast guard funding because they worried that the armed services did not sufficiently protect their shores. The event was never held. My father calculated his expenses and profits in pencil below the director's signature and probably decided that, while the donation to the Coast Guard would attract attendees, it would cut too much into his profits.

After the war, the Swing Era faded, and young men no longer

filled the city. To attract servicemen en route home and women who fondly recalled romantic wartime evenings, he held "The First Annual Reunion and Dance," on Christmas Eve 1947, at City Center's Grand Ballroom on West 55th Street. He invited "canteen girls" to "meet their friends" for $1.04 and GIs to meet their "buddies" for half that amount. To encourage sales, he offered "free admission" to members who sold "5 tickets in advance," a door prize for those who sold "10 tickets or more," and a grand prize to the "girl who sold the most" tickets. This was his last dance. His "reunion" strategy was not a success, since soldiers returning home had no need for entertainment.

My father tried new schemes; some did not pan out. In 1949, with a Con Edison co-worker, he applied for a patent for an attachment that prevented a blown fuse from disturbing other outlets in a residence. I don't know whether he never received the patent or they never manufactured the product. He tried to produce and market a bronzed coin bank with the image of Bojangles—Bill Robinson, a black tap dancer who began to perform for white audiences in 1928 and appeared in movies and Broadway musicals. In December 1949, he signed an agreement with Robinson's widow and his manager, Marty Forkins, to allow him and Bush Metal Products to manufacture and sell the bank. As far as I can tell, this item was never produced or sold.

In the late 1940s, my father had seen a business possibility in postwar New York City's booming tourist trade. With Bill Welborn, a fellow meter tester who understood metal manufacture, he had formed a partnership called B&B Sales and rented an office east of City Hall. First they'd marketed painted metal toy soldiers, which

had been popular in wartime. Then they'd come up with the idea of selling souvenirs of New York City, bronze-plated Statues of Liberty and Empire State Buildings, cheap mementoes of iconic monuments in a city that was now "the capital of the world."

The models had capitalized on people's association of bronze with the monumentality and permanence of public commemorative statues. Solid bronze was heavy and expensive to produce, especially during and after the war. So the partners had created a product with the look of bronze, by plating models made of a cheap zinc alloy variously known as "white metal," "pot metal," or "spelter." Welborn ran a rented loft factory on the Bowery, while Bill Turbin's role was sales. As a promoter of dances in Manhattan ballrooms, he knew managers of midtown hotels who could help him place items for sale in their gift shops.

In the early 1950s, the partnership ended, I believe amicably, and my father formed his own company, Souvenir Sales, and made a deal with Bush Metal Products, on Bushwick Avenue in Brooklyn. For the next half-century, from the 1940s to 1990s, he sold the cheap, shiny metal miniature replicas of Statues of Liberty and Empire State Buildings that loomed so large in my childhood.

Inwood Park in 1942

5.

Basements

AFTER HE DIED, MY HEART ACHED for the father I saw in snapshots taken when I was an infant and toddler. He had a box-shaped black Eastman Kodak Six-20 Brownie with a black-and- silver geometric pattern, a round lens, and two gleaming eye-like openings. In one photograph he gazes at me lovingly as he holds me in his arms. In another he smiles broadly as I sit astride his shoulders. I feel no such intimacy in snapshots of my mother with me. She sits on a windowsill of our corner brick building, facing a courtyard with shrubs, smiling graciously for the camera. I, asleep, lie low in her lap. At the beach, she smiles, holding me, wailing, away from her body. She, the model and beauty, is the subject of the picture. If my mother had had her choice, I would have been called Barbara, but Lil got the name first for her daughter, who was born the month before me. My grandmother Pauline wanted to call me Deborah after a deceased relative. But

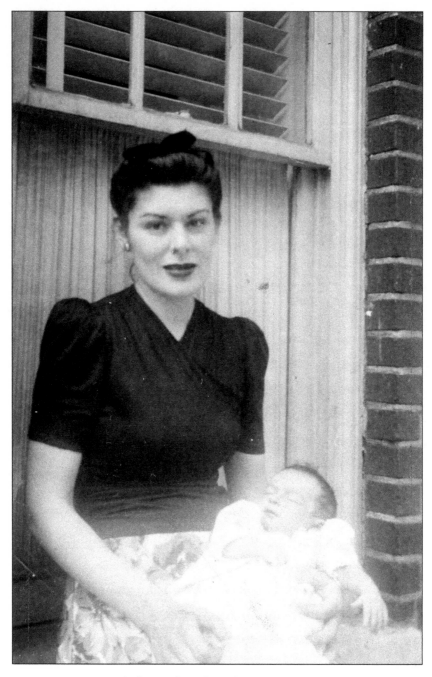

In front of 100 Post Avenue in 1942

my father, like millions of other Americans in 1942, chose Carole with an "e," after Carole Lombard, the willowy blonde film star and wife of Clark Gable, who had died in a plane crash that year. He often said he admired her because her parents were Baha'i, a faith advocating world brotherhood, which he followed on and off all his life.

It was my father, not my mother, who filled in the blank spaces in an illustrated booklet designed for new parents to record their newborn's vital information. I recognize his handwriting, which is uncannily like my own became years later. On the first page, the new baby exclaims, "I left the country of the stars and came down to earth today." He noted my birth on Monday, May 4, 1942, at 2:00 a.m., my weight, seven pounds, seven ounces, and my parents' and the doctor's names.

In a snapshot of my father holding me, Post Avenue, in Inwood, is a treeless, canyon-like street of five-story apartment buildings with fire escapes. My mother must have chosen to live in the Bronx and then upper Manhattan to be close to her family. My father had always resided downtown. Lil probably helped them find the one-bedroom, fourth-floor walk-up near 207th Street, since she, Sam, and five-year-old Bobby lived on the fifth floor. It was a desirable neighborhood, far from the poor, crowded downtown areas and, like Manhattan's Upper West Side, relatively new. Their neighbors, like themselves, were American-born, from New York or nearby states, the children or grandchildren of immigrants from Ireland, Germany, Great Britain, and Russia employed in service or modest white-collar occupations.

When I was an adolescent, my mother often complained to me

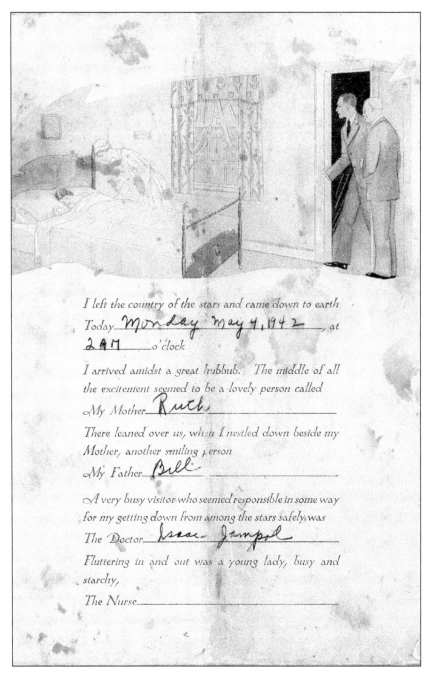

My baby book

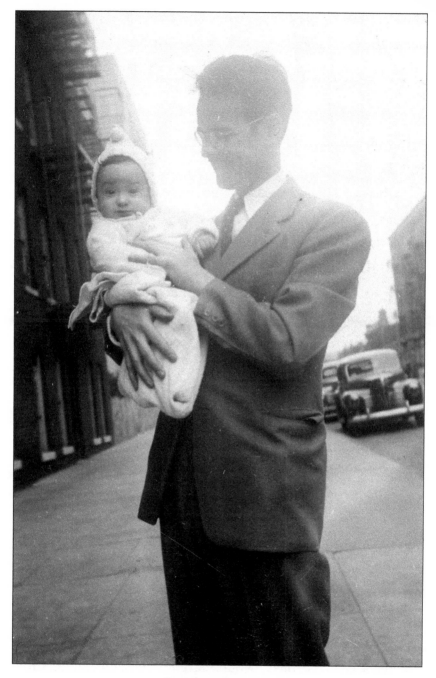

Post Avenue in 1942

y father. She had discovered his bad temper and crude lan-
after only a few weeks of marriage. He was not the charming,
ɪtive man she had fallen for. Though she met him at a dance,
sɪɪe now felt it was not a respectable business and encouraged him
to drop it. Perhaps, also, she imagined him flirting, as he had with
her at that dance, and suspected that he was unfaithful. He was,
with Drusilla Megee.

When my father married, I doubt he recalled that, five years be-
fore, at twenty-four, he had vowed to his diary that he would give
up his "precious" freedom only for "real" love or money. He mar-
ried Ruth Fiedler for neither money nor—as he informed me in
2004—for love. People were nagging him about marrying, she was
attractive and came from a good family, and he became infatuated
when she played the "Moonlight Sonata." Still, in one way he was
true to his vow: He did safeguard his freedom.

He also told me that my mother was "cold," which I took to
mean that she was sexually unresponsive. She was a gracious
rather than an earthy beauty, proud of attracting men's gaze with
her looks and style. Many times I heard her criticize women with
an erotic presence as "oversexed." Yet since sex in marriage is in-
separable from love, perhaps she could not feel or express physical
warmth toward her husband because she sensed no love. I suspect
also that his physical needs differed from hers; for him, sexual
gratification was more important than love or beauty. He wrote
that "sexual stimulation" and "fondling" were "life's most signif-
icant experience." Couples who didn't "delight" in "stroking each
other's erogenous zones" would have an "unsatisfying relation-
ship" even if they were "close emotionally." Women who "primp"

to "attract" their husbands "are wasting their time."

Often my mother referred to him as her "youngest child" and, with a deep sigh, said that at least he was more ambitious than his brothers, my uncles Charlie, George, and Irving. In the 1970s, as a feminist, I asked her why she never left him. She replied that her mother had died young, so she had nowhere to take her children. I understood. Until the late 1960s, when marriage was no longer the be-all and end-all for women and few jobs were available to married women with children, divorcées were at best pitied and at worst shamed. Often they took refuge with their mothers and struggled to earn a living. Yet I wondered why she hadn't ended her unhappy marriage before I was born or shortly afterward, well before her mother died. Even in those years, some women did so. In the 1940s my father's younger sister divorced her straying husband, despite having an infant son, and then met and married another man.

I believe that my mother didn't have it in her to pick up and leave. She disapproved of aggressive women. She once told me that she could have married Martin Abzug, a lawyer, but chose my father instead because he was more exciting. Abzug was in the news because his wife, Bella, known for big hats and assertive feminism, was a Congressional representative (1971 to 1977) and mayoral candidate (in 1977). My mother remarked that she felt "sorry for Marty, such a sweet, quiet guy," for having an aggressive wife. A moment later she added that she knew she "shouldn't have said that." I surmised she understood that I admired Bella Abzug's toughness, but in her passive way backed off from openly opposing my views. I did not argue with her.

Also I believe that she wanted most of all to be an American wife in her own household, not a daughter living in her immigrant parents' old-fashioned home. She loved her new, modern things—chairs

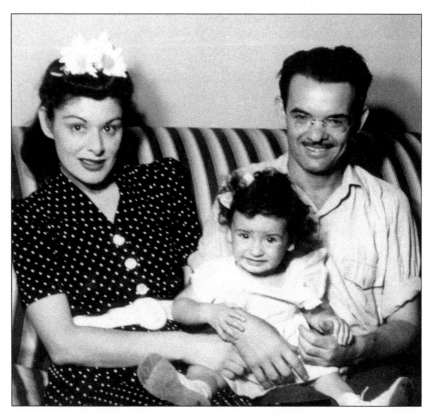

Sitting on the striped sofa in 1944

and a sofa covered with a shiny satin-like brown-and-beige striped fabric. A deep blue wool carpet. Lil and Sam's wedding gift, Community Plate's Coronation pattern silverware in a green-tinted, satin-lined wooden box. Lu-Ray Pastel dishes in a modern grayish-pink color. Stainless steel Revere Ware pots with copper bottoms, a recent improvement over heavy cast iron. Nathan and Eva's gift, two dressers, two bedside tables, and a vanity with a tall mirror, all with

a burled walnut veneer and brass drawer pulls with burnt orange Bakelite rectangles.

One of my earliest memories is of a day in January 1945 when my mother returned from being away, I knew not where, carrying two bundles wrapped in pale blue blankets. My grandfather Nathan had taken care of me when my father was at work. Curiously, I observed her placing my infant brothers side-by-side on the bed where she and my father slept. When I was older she explained that, after the doctor delivered Richard, on December 25, 1944, he exclaimed, "Wait, there's another one!" Six minutes later, Ronald was born. When my father, known as a practical jokester, telephoned Nathan and Eva to say that Ruth had given birth to twins on Christmas Day, they did not believe him. My mother hired a professional to photo-

Ronald (left) and Richard (right) in 1945

graph her photogenic babies lying on a blanket, their large dark eyes looking up at the world.

The next year was filled with the wailing and sour odors of two babies. Every few hours my mother warmed infant formula on the stove and splashed a few drops on her wrist to test the temperature. Her doctor had directed her to feed us bottled formula on schedule, every four hours, no matter how much we cried. When I was a child, she would describe how upset she had been by my own frequent and vociferous wailing. I must have been ravenously hungry between feedings, as I still am when a meal is delayed. As she bottle-fed or changed the diaper of one squirming, fussing twin, the other screamed. She would rinse the smelly, yellow-brown-stained cloth in the toilet bowl, flush the toilet, and then deposit the wet diaper in a white enamel pail, ready to send out for washing. To take us outdoors, she had to climb up and down four flights of stairs, carrying my brothers, while I toddled beside her. After shopping, she would make more trips up and down stairs with the groceries.

One day, my mother guided my brothers' double stroller with one hand and held my hand with the other as we crossed 207th Street toward the elevated subway on 10th Avenue. I tripped over the metal trolley tracks, lost hold of her grip, fell on my face, and broke my nose. It must have been a weekend when my father wasn't working, as he, not my mother, took me to a hospital. I lay on an examining table with white cloth padding, like the ironing board on which my mother smoothed wrinkles out of clothing. Under yellow lights, people with kindly faces looked down at me.

Recalling this incident in in 2004, my father said, gruffly, should have looked where I was going. I reminded him that barely three years old. He softened, admitting that I was fortunate; I hadn't needed surgery as he had, because the break was "clean." And my vision was not damaged. Mostly he recalled how loudly I screamed when the doctors took me from his arms. This was his tender side, the father who responded to my nighttime cries and instructed me to draw what I feared. I felt that my broken nose was a part of our bond.

After my brothers were born, my father embarked on a quest for larger living quarters. He insisted that we'd had to leave the one-bedroom walk-up because "children need light, air, and space." This was not easy, because the demand for housing was high and the supply was limited. My brothers and I were war babies, part of a boomlet that began during the war, before the baby boom. The city's emerging war industries had attracted workers who rented housing in Inwood and nearby Washington Heights, and no new buildings were constructed because raw materials were reserved for the war. Cars, bicycles, stoves, tires, fuel, rubber, and footwear were also scarce.

My father often described, with great zest, how he had acquired our house in Queens. First, he tried bribing the superintendent to secure a larger apartment on the ground floor. Then an acquaintance told him about a frame house for rent in Auburndale, west of Bayside, a few miles from Long Island's opulent North Shore. He inspected the place and liked what he saw: two stories, three bedrooms, and a big backyard. He could get to Penn Station with the LIRR in forty minutes and walk to Northern Boulevard, where there

The house in Auburndale, Flushing, Queens in 1961

were shops and buses to Main Street. There he could take the subway to Grand Central and Times Square.

The owner, a Mr. Westhoff, agreed to rent to him, but my father heard nothing for a few weeks, so he traveled to Auburndale by subway and LIRR to check on the deal. Luckily, the current tenant, who was planning to move, was at home and willing to talk. She explained that my father's acquaintance had also told another person about the rental, and that Westhoff had given the interloper the

keys. But no lease had been signed. My father knew that a rental was not legally binding without a lease, so he decided to confront Westhoff directly. The landlord, being old-fashioned, had no phone, so my father obtained his landlady's number in Brooklyn and learned that he was at the movies. To get to Brooklyn from that part of Queens, he had to take the LIRR to Manhattan, and then a subway. While waiting for Westhoff to return from the movies, he prepared a lease on a blank sheet of paper. When the landlord appeared, my father used his selling skills to persuade him to sign because he had agreed to rent to him, Bill Turbin, first. Westhoff signed. Then my father journeyed back to Auburndale. On his way, he hired a locksmith to change the lock. At that moment, he was the sole possessor of the keys to the house.

We moved to Auburndale on a cool spring day in 1945, when I was three. As I peered out a side window of the car my father had borrowed from one of his many cousins, we passed the half-circle hangars at La Guardia Airport on Grand Central Parkway. At Northern Boulevard, we slowed and then turned north to 195th Street. Shaded by maple branches arching over the road, the street spanned a block from a fieldstone wall surrounding an estate to Station Road, which was lined with woods. Our grassy backyard ended in a row of stately cypresses, through which we glimpsed houses on the next street. Mid-block was a weedy field where, later, my friends and I dug in the mud and climbed trees. It was so quiet that my grandmother Eva said that if you "pull down your pants to pee in the road, no one would know."

The evening of the day we moved in, I sat on the bottom step of narrow, steep stairs that curved from the dining room to the

second floor, peering into shadows and listening to unfamiliar sounds in empty rooms. The dining room's sole furnishing, left by former tenants, was a crystal chandelier, sparkling in the half-light. My tall father, on his way from the living room to the kitchen, hit his head on the dangling glass and muttered, "Goddamit to hell." The next morning I saw the chandelier's shiny remains in a heap on the dusty, unpaved sidewalk, waiting for the trash collection.

In 2004 my father told me that Mom had said nothing to him about the new home, never even thanked him. To me she said only that she had never had so much space. I suspect that, if he had consulted her about renting the house, she'd passively accepted. She knew nothing of Queens but she wanted a house, not a cramped apartment.

However, this was not the one of her dreams. The lot and house were narrow, the gray shingles dingy, and the rooms small. When we switched on the kitchen light, legions of cockroaches scurried across the floor into the old stove. She envied her sister Lil's new suburban home in Connecticut with four bedrooms, two bathrooms, wall-to-wall carpets, and Danish Modern furniture, which Uncle Sam had helped her choose.

I'm sure my father had no idea how much my mother's life now changed. His weekdays were much the same as before. In the morning he and other men would stride to the LIRR station in dark suits and fedoras or, in cool weather, long black wool coats. Since he was often late, he used to set the clock on the kitchen wall back fifteen minutes to fool himself into being on time for his train. My mother spent her days at home like most married white middle-

class and working-class women. She was far from family and child-hood friends, and at first she was at a disadvantage because she did not know the butcher. During wartime rationing, only long-time patrons were favored with extra meat. In those years when meat was scarce, occasionally we had Spam for dinner; it tasted mostly of salt.

Sometimes when my father returned from work he would teach me to read words in the Daily News comic strips. In the morning, before he went to work, he often listened to me reciting the alphabet. If I said I felt ill, he urged my mother to keep me home from school. When I stayed in bed with what the Con Edison doctor, in his dark blue suit and red tie, said was the "grippe," my father brought me a coloring book or modeling clay. One day he returned home with the second-hand red tricycle (new metal was scarce after the war), pictured in a snapshot of me with Lulu, a black cat with white chest and paws. When I outgrew that, he bought me a two-wheeler and taught me to ride. As he relaxed in an armchair after dinner, I would stroke the hair on the back of his neck.

My mother would often say that money was short. We had a small refrigerator with a tiny freezer compartment—we could not afford a large one—and an economical "party line telephone," shared with another household. She replaced broken Lu-Ray din-nerware by redeeming S & H Green Stamps, which she had pasted into booklets, or supermarket offers—a plate for so many box tops from laundry soap. My father nagged us to turn off lights whenever we left a room, to save money on electricity.

She decorated the house as best she could. Nathan, now over sixty, spread canvas drop cloths on the floor and mixed paint for

Lulu and me in the backyard in 1948

the walls—there were no pre-mixed colors in those days. He gave the kitchen cabinets a grained wood faux-finish. She hung Uncle Harold's artwork on the walls. When I looked at his pictures, I en-

Hal Fiedler, *Shipfitters*, 1940s. Silkscreen.

tered a magical world, so different from the ordinary things and people in my everyday life. I admired the long, slim limbs of a ballerina, seated in a lacy tutu, gracefully stretching to touch her toes. I peered

curiously at the men with headlamps who welded structures in the dark underworld of a ship's hold. (The Metropolitan Museum of Art owns a copy of the silkscreen print "Shipfitters".)

These figures were like characters in books my mother read to me and I later learned to read myself, such as Pride and Prejudice and Little Women, which she borrowed from the wood-paneled public library on Bell Boulevard. I couldn't get enough of these imaginary worlds. In grade school, I often grew restless from sitting in a seat for hours, so I would read a novel that I hid on my lap under the desk (or so I thought) from the teacher. When I was old enough to ride a two-wheeled bicycle, I pedaled to the library and persuaded the librarian to let me to borrow young adult fiction. Books for my age were too simple. I re-read some, like Frank Gilbreth's Cheaper by the Dozen, ten or fifteen times, enjoying the familiarity of the characters and the plot.

That first year in Auburndale I could sense my mother's disappointment when a van delivered a used mahogany-stained dining table, chairs, a glass-fronted china cabinet, and a buffet, purchased from a newspaper advertisement. Her heart must have sunk when she noticed a triangular stain, which the sellers had hidden with a decorative cloth; she did the same with a circle of white lace, on which she placed a candlestick. The lace remained there until just before she died in 1991, when my father sold the house.

I knew we were different from our neighbors. My playmates on the block attended a Roman Catholic school and warned that, if I didn't convert, I would burn in Hell. I wasn't frightened. I didn't take their threats seriously and was proud of being Jewish. My mother kept us home from school on Yom Kippur and Rosh

Hashanah and joined a reform temple; she wanted us to know who we were. She always referred to the two other Jewish families in the neighborhood as German, though I hardly knew what that meant for someone with her Eastern European roots. During the 1952 presidential campaign my parents supported Adlai Stephenson, though our neighbors' signs proclaimed, I Like Ike. As she took me with her to the polls, at a shop on Northern Boulevard, she whispered that I shouldn't tell anyone how she had voted. "Why?"

"Voting is a private matter."

Though there were only two cars on our street—Mr. Jordan's yellow Checker cab next door, and Mr. Hered's black 1930s sedan across the way—there were usually many people and vehicles coming and going. Portly Mrs. Jordan sat knitting in a chair in her driveway and looked up to greet me as I walked by. The Dugan Brother's Bakery truck delivered ring-shaped yellow cakes with honey and nuts. Horse-drawn carts driven by a knife-sharpener or junk dealer clip-clopped by our house; scrap metal was valued during and just after the war. Before dawn, Grandview Dairy delivered bottles of non-homogenized milk to our back porch. On coal delivery days, a large green truck pulled up. I was sure its white-lettered Burns Brothers referred to burning fuel. Men in dark brown uniforms inserted a metal chute through a basement window. Shiny black lumps rattled into a wooden bin, creating shadowed hills and valleys of coal.

I felt important when I walked with my mother to the grocery store on Northern Boulevard. She handed a list to a white-aproned clerk, who stood behind a polished wooden counter. He retrieved prepackaged items, weighed and wrapped goods, and packed it all

Learning to play the piano, clockwise from top, 1943, 1945, 1948

in brown paper bags. A few years later, the store was replaced by a King Kullen supermarket and parking lot, which spanned an entire block. After that, my mother and I pushed a metal cart along wide aisles and selected colorful packages, which we took to the checkout counter.

My mother's dark-stained upright piano stood tall and important in the living room, next to the windows to the front porch. She used to tell me that she had begun teaching me when I was old enough to reach the keyboard. Soon after moving, she took a course at Julliard School of Music in Manhattan and put a sign in the window: Piano Lessons. Julliard trained. Then she replaced the upright with a fashionable blonde wood spinet. When she gave lessons, the living room was her private space, so, after school, my brothers and I entered the house though the side door. Many decades later, she gave me a gold ring studded with garnets, which she had bought with her first piano teaching money, and then a ring with diamond chips and a diamond. These were treasures that my father could not or would not buy for her.

In the early 1950s, when I was nine or ten, hissing, clanging steam shovels and steamrollers leveled fields, woods, and the estate. Workman extended our street to Northern Boulevard and dug foundations on the new street and along Station Road. Since the construction sites were neither fenced nor guarded, we played in mounds of earth when the workmen departed. Soon Jews and Italian-Americans from the Lower East Side and the Bronx occupied new two-story, red brick attached houses, with garages. Our new neighbors had children—the baby boomers—and parked their cars in driveways or on the street. Auburndale was now part of Amer-

ica's suburban car culture.

My favorite part of our house was the basement. The furnace was fascinating. It had wide arms reaching to the ceiling and a black iron grate, behind which red and yellow flames flitted. On cold mornings I felt comforted by hissing sounds of steam traveling through pipes from the basement to the metal radiators. The warm air rose to the ceiling, so at breakfast I ate buttered toast standing on a chair with my head and shoulders surrounded by hot air. My mother warned me that, if did that, I would grow tall. This worried me, as I was already taller than other children, but I continued to do it.

On winter mornings I often followed my father down steep stairs and watched him shovel coal from the bin to the furnace. Once he explained that a fire needs air to burn and showed me how to lift the metal lever that opened clattering iron slats. Sometimes I ventured to the basement alone and gazed at the orange blaze and red-hot embers, which slowly became cinders. In the evening I would watch him shovel ashes into a metal bucket and carry it to a metal trashcan, which stood by our side door. When it was icy outdoors, he spread ashes on the front and back stairs, and the unpaved driveway and sidewalk, to prevent us from slipping. After a snowstorm I liked to draw lines in the snow with a handful of ashes and create eyes in a snowman with bits of unburned coal.

I admired my mother's strong hands as she rubbed soiled clothes on a washboard in the double sink beneath the basement's rear window to loosen stains before running them through the washing machine. I loved looking through the round window in the white Bendix to see the clothes tumble in bubbly patterns. When the wash

cycle ended, my mother would expel moisture from the clothes by inserting them between cylinders in a mangle and rotating the handle. She told me that, when she was a child, only wealthy people had washing machines, so her parents had sent soiled clothing and linen to a commercial laundry. It had been her job to dry the wet wash with a heavy iron, which she heated on the kitchen stove until the water inside turned into steam.

It was my job now to hang wet clothing and linen out to dry. On rainy days, I draped damp clothes on a wooden rack in the basement. When it was sunny, I carried them upstairs in a wicker basket

Laundry hanging in a neighbor's yard in Auburndale, 1961

to the tiny back porch. Feeling important, I stood on a stool by an open window and reached outside to pin clothes onto a cord attached to pulleys on the garage in the backyard. A few years later, when my parents bought a clothes dryer, we no longer hung our laundry outside. This was a sure sign of prosperity, like a television aerial became in the 1950s.

The first Sunday morning of each month was a special occasion. Mr. Westhoff, an old man with gray hair and a goatee, clad in a dark suit, white shirt, and tie, would visit us to collect rent. As he sat at the tiny table next to the kitchen window, my mother cooked pancakes and my father chatted with him. About three years after we moved in, he died and willed the house to my father.

I believed then that Westhoff's gift was a reward for my father's generosity and hospitality. It wasn't. When he told the story in 2004, he explained that he "knew on which side" his "bread was buttered," so he treated the old man well, "better than his own family." Knowing the lonely old man would enjoy a family meal with children playing nearby, he'd asked my mother to cook the pancakes. His scheme was to purchase the house by paying the same amount monthly as the rent. Westhoff had not only agreed but also, without telling him, willed him the house and appointed him executor of the estate. My father went to the old man's funeral, where he endured the family's black looks.

My parents replaced the cockroach-infested stove and hired carpenters to transform the pantry into a dining area. My grandfather Nathan papered the walls and painted the new wooden cabinets above the counters a fashionable light brown that he called "sandalwood." Workmen converted the coal furnace to an oil-burner—

A coal furnace converted to an oil-burner, similar to the one in Auburndale

no more black dust and ashes in the basement, shoveling coal, or waking up to a cold house. My parents could regulate the heat with a thermostat on a living room wall, which my brothers and I were forbidden to use.

The basement still possessed mysteries. Often my father sat on a stool at a workbench and wrote orders on forms, which he kept in dark green metal file drawers. More often he prepared bronzed models of Statues of Liberty or Empire State Buildings by gluing small squares of green felt to their hollow metal bottoms. One base-

Decals, gold-toned chains, and thermometers.
Photograph by the author.

ment wall was lined with stacks of corrugated cardboard boxes of varying shapes and sizes, many battered from shipment. My father wrapped each souvenir item in newspaper and packed them into these cartons, which he sealed with gummed paper tape, moistened with a damp sponge, and tied with twine, ready for Saturday deliveries.

Sometimes I dared to explore cartons on shelves in a narrow room in the front of the basement, the former coal bin. I pulled out a white ceramic ashtray with an image of the New York City skyline or the Coney Island parachute jump, or shook a snow globe to evoke a blizzard. I found bronze-plated seated Buddhas, with laps designed for burning incense, bamboo back-scratchers with Chinese characters, and a sleek gold-toned letter opener with a handle shaped like an elongated nude woman with red jewels in her nipples.

Most boxes were filled with Statues of Liberty, Empire State Buildings, or horses with saddles and stirrups and a brass or silver chain threaded through their noses. The bronze tones were luscious, deep brown tinged with gold, and the plating was smooth and cool to the touch, with rough seams from the molds that formed them. They came in many sizes—from a few inches, like the Statue of Liberty dinner bell, to about ten inches high. The larger Empire State Buildings had a space in front for a tiny glass thermometer filled with alcohol colored with red dye and stapled to a gold-colored cardboard backing marked with temperature measurements. Items that did not have a New York theme, like the models of Buddha, had medallion-shaped decals pasted on them, with the words "Souvenir of New York City."

Sometimes my father showed my brothers and me novelties that he intended to add to his line. He explained that a cone-shaped plastic pull, designed for the end of a venetian blind cord, could be fitted with a tiny bulb and glued to the top of a Statue of Liberty's raised arm. He drilled a hole in the torch and another in the shoulder joint, wired the bulb's socket to a cord, and ran the cord through the hole. When the cord was plugged in, *voilá*, Miss Liberty's lamp was lit.

In the basement lay a trove of comic books that, in my pre-television childhood, were a source of magical fantasy. One of my father's many cousins sold comics to newsstands and stored the unsold copies in our basement, with titles cut off to prevent them from being resold. Alone in the dim light, I undid the twine on the bundles and read them all: Little Lulu, Nancy, Archie and Veronica, Donald and Scrooge McDuck, Superman, Batman and Robin, and Dick Tracy. There were stories from literature, such as The Hunchback of Notre Dame and horror tales like the one about the Heap, a stalking creature whose body was a hairy green blob.

Often on weekends I helped my father in the basement, and when my brothers were old enough they did, too. I felt grown-up as I arranged rows of green squares of felt next to rows of Statues of Liberty and Empire State Buildings, as I had seen my father do. We would pick up a statue, touch the edges of the hollow bottom to glue spread on cardboard, and place it on a square of felt. The statue's bottom had to have just enough glue to stick to the felt but not so much that it oozed onto the sides. Sometimes we squirted glue from a Duco Cement tube onto thermometers or decals and stuck them to the sides of statues, or we threaded brass-toned metal chains through the noses of metal horses. I found the precise repet-

itive motions soothing and loved seeing the rows of models in
of me increase. When I was old enough to manage a sharp knife,
my father showed me how to slice the tape that held a cardboard
box together so it could be flattened and re-used. Chatter irritated
him, so we worked silently, while a radio played popular tunes.

My father paid us by the piece, and my brothers and I became
adept assembly line workers. At one time or another most of my
brother's friends and our eleven male cousins earned money by felt-

My cousins and brothers in 1958. Ron is on the far left, top row,
and Rich is fourth, same row, next to Aunt Bertha.

ing souvenirs in our basement. One employee was a handicapped
neighborhood boy who uttered only grunts and moved spasmodi-
cally. For him the work was occupational therapy. At my father's
funeral in 2005, my brother Rich asked, "How many in this room

put felts on Statues of Liberty in our basement?" It seemed that half of the audience raised their hands.

Before my father had a car, he would make a business agreement with a relative who owned a vehicle to help him deliver merchandise to customers on Saturdays. One arrangement was with his cousin Julie, with whom he had picked up girls on the Lower East Side. The last was with Uncle Al, who was married to Aunt Bertha, my father's favorite sibling. I looked forward to the Saturday mornings when Uncle Al drove his station wagon to the side door of our house and greeted me with a hug before he had coffee and a Danish pastry in the kitchen. Then he and my father carried cartons upstairs from the basement to the wagon and drove to Manhattan.

My father and Uncle Al, a blacklisted schoolteacher, often argued about politics. My father hated Communism, not as a Cold Warrior who feared the CPUSA's threat to America's way of life, but because he despised Stalin, "a vicious dictator who murdered more people than Hitler." One morning in 1953 he told me to take to school for Show and Tell a newspaper clipping of Stalin's death, a world-shaking event. And he disapproved of the Communist adage "Religion is the opiate of the people." A fiercely independent rebel who hated authority, in his own way he believed in God and in capitalist enterprise.

I had seen chilling television images of anti-Communism (the 1954 Army-McCarthy hearings) and Communism in action (tanks rolling into Budapest in 1956), but I didn't associate these with my affectionate aunts and uncles. I wanted to know more, so when a teacher assigned a research paper on a foreign country, I requested information from the Embassy of the Union of Soviet Socialist Re-

publics in Washington, DC. Soon a magazine, USSR, with Lenin on the cover, addressing young people with rapt faces, appeared in the mail. My mother said that I should hide it; if my father saw it, he would be furious. I dutifully squirreled it away and found it, decades later, after he died.

Having observed rows of bronze-plated models on shelves in Woolworth's, Lamston's, and shops in plush midtown hotel lobbies, I believed that my father was influential. He boasted of selling to the Edison, the New Yorker, the Gramercy, the Pennsylvania, and the St. George in Brooklyn Heights. His merchandise stood alongside paper fans in Chinatown, in store windows in Times Square— the "Crossroads of the World"—and in shops near the West Side piers, where sailors from naval vessels, freighters, and ocean liners bought clothing, shaving equipment, and gifts for a hometown girl. My father would say, "People from all over the world visit New York for once in their lifetime. What do they buy to bring back with them? One of my souvenirs."

He often boasted that his one-man operation competed successfully with New York's two other souvenir businesses, both "million-dollar divisions of multi-million-dollar corporations." This was possible because his operating costs were low, due to frugality and fraud. He was a saver. He wrapped items to be delivered in old newspapers, packed them in boxes he saved from shipments, and tied them with hoarded string and twine. His basement workplace probably violated residential zoning regulations. He did the work himself or employed a relative or his children and nephews, which must have violated child labor laws, not to mention that we worked in acrid glue fumes, with no ventilation. He told me that, once, he

had bought novelties stolen by a shipping clerk, sold them below cost, and split the profits with the clerk. When the owner of the business discovered the losses, he fired the clerk's supervisor but not the clerk.

My father's fraud extended to dealings with Bush Metal, the manufacturer of his bronze-plated models. In these years, visitors to New York City—mostly American, because transatlantic travel was so expensive—would have been offended to find foreign-made souvenirs for sale at the Statue of Liberty and Empire State building. Americans took pride, not only in their country's monuments representing democracy and economic achievements, but also in its well-crafted domestic products. Imported souvenirs were made in Taiwan and Japan, which were known for cheap, poorly made goods, and only a decade before Japan had been a reviled enemy. Bill Turbin had exclusive contracts with high-profile shops at the Statue of Liberty and Empire State Building because his souvenirs were the only ones on the market that were manufactured in the U.S.A. But his bronze-plated models were as tawdry as the imported ones; Miss Liberty's features, cloak, and pedestal were crudely sculpted, with little attention to aesthetics, and the manufacturer did not smooth the mold seams on either side. But Souvenir Sales could match the low price of imported versions, because Bush Metal charged a low rate in exchange for cash "under the table." In this way, the owner avoided paying tax on the income.

The business, my father's pride and joy, was nevertheless his side job. Most of the day, as a Con Edison meter tester, he would carry a heavy bag of tools from one basement to another in Harlem. To gain time that he needed to phone customers, visit souvenir shops,

or re-charge with a half hour nap in a corner of a dank basement, he tested many fewer meters than the company required. He justified cheating Con Edison because it was an enormous company whose goal was profits at the expense of people who bought electricity. He sympathized with poor people who couldn't pay their bills and never reported "jumper wires." To avoid having to return his heavy tools to the company office in the evening, before leaving the last job of the day he gave the building superintendent a few dollars to safely store his equipment until the next morning. Then he took the subway downtown to headquarters, put his uniform in a locker, and donned business attire.

Occasionally he surprised my brothers and me with a treasure he had found in a basement. One was a dusty multi-volume encyclopedia with black-and-white illustrations and photographs. I opened a volume at random and read entries about exotic places and animals, like prehistoric creatures and transparent, sightless fish that inhabited tunnels deep under the sea where no light penetrated.

Since my father needed a delivery vehicle, and our home had a driveway and garage, he decided to buy a car. One evening my mother, brothers, and I waited impatiently for the sound of wheels in the driveway. He must have bought the used light blue Nash Rambler, a two-seater with a black canvas convertible top, on impulse because it was cheap. The top leaked when it rained, and water from puddles splashed into the interior from a hole in the floor near the gas pedal. He grumbled when I complained that I could barely fit in the narrow area behind the front seat. He never openly admitted that he had made a mistake, but after a few weeks he sold it and bought a black sedan. This one did not leak and had space

for a family of five and a trunk with ample room for deliveries.

My mother wanted to drive the car, which was parked in the driveway during the week when my father didn't use it. The new supermarket had a parking lot, Bloomingdale's had opened in the Fresh Meadows shopping center, and we had discovered Jones Beach's wide, soft sands and pounding surf. With a car, she could visit Nathan in the Bronx without taking two buses, and give piano lessons to pupils who were unable to travel to her. But my father was old-fashioned. He criticized her new short coiffure; it made her "look like a man." He refused to go to the female doctor whom my mother paid out of pocket because she disliked the one provided by Con Edison's health insurance plan. And he decreed that "women should not drive."

Swearing my brothers and me to secrecy, she took lessons from a woman on the block. To her surprise, she passed her first test despite braking the car so abruptly that the inspector's hat fell off his head. He just said that sometimes you have to stop suddenly. It happened that my grandfather Sam was visiting that day. (My mother disliked his visits because he arrived unannounced, sat in a chair in the backyard, and when the need arose, peed in the mint plants under the back porch.) Sam heard my brothers and me talking to my mother about her success and didn't realize that it was a secret from my father. So when he returned home late that evening, Sam blurted out that Ruth had passed her driving test. My father seemed mildly surprised rather than angry, though I don't know what he said to my mother in private. I only know that he refused to be a passenger when she was driving, but he could not prevent her from using the car when he was not home.

The car I recall most vividly was a red General Motors station wagon. It must also have been a bargain, since it was dented and had a soiled and torn beige interior. My father explained to my brothers and me that, if we came with him when he made deliveries, he could avoid paying traffic fines; if cops saw children in the car, they would not issue a ticket for parking double or at a fire hydrant or bus stop. I hated these excursions. We drove west on Horace Harding Boulevard and crossed the East River through the Midtown Tunnel, rattling over potholes and trolley tracks only partially covered with asphalt. My father was an irritable driver who cursed cars and trucks that moved too slowly or too fast. When my brothers

The red station wagon in the driveway of the Auburndale house in 1961

and I squabbled in the back seat, he yelled, "Shut up, for Chrissake," twisted his head toward us, and raised his arm. I hated waiting in the car while he carried boxes to shops. When the windows were closed, it was stifling, and when they were open, we smelled fumes from passing vehicles. My brothers would nudge each other and whisper in their private twin idiom; they had no sympathy for my distress.

One spring morning when I was about eleven, as my father packed the car, I rebelled. Without a word I ran a few blocks away and walked about to calm my resentment. After a half an hour or so I returned, anticipating punishment. He greeted me calmly, drove off with my brothers, and never again asked me to help with deliveries. In my own way, without saying anything, I had made my point.

About the time that I began Bayside High school in 1957, my parents, like other suburbanites, "finished" the basement. A wall separated the oil burner, washing machine, and dryer from a recreational space, where my brothers and I played ping-pong on a green plywood table. The walls were lined with shelves on which my father stacked boxes of merchandise, and he used the plywood table for gluing green felts to the bottoms of Statues of Liberty and Empire State Buildings. Since he didn't protect its surface, bits of glue and felt adhered to the plywood, causing the ping-pong balls to career off the table unpredictably.

My parents decorated with fashionable 1950s colors—pink walls and pink-and-black floor tiles. But a waste pipe, also pink, rose from floor to ceiling. Hot and cold water pipes and electrical wiring ran along the rough wooden ceiling beams. The paint didn't

mask the cinder block construction of the walls, and the linoleum was as uneven as the concrete floor it covered. But it was still a basement, my father's workplace, and my favorite part of the house.

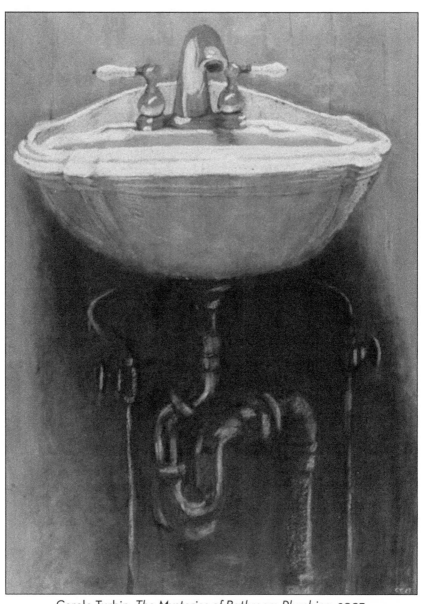

Carole Turbin, *The Mysteries of Bathroom Plumbing*, 2007.
Wax, black ink, charcoal, and conte crayon on paper.

6.

Plumbing

A S A CHILD, I OFTEN WISHED I had a transparent window in my stomach, like the little boy in a story my mother used to read to me. I pictured it like the round glass in the door of the washing machine in the basement. With such a window, when I had a digestive upset I could see what was happening inside me. I worried that something could go terribly wrong with my internal plumbing. This fear was a visceral representation of other terrors in my life in the 1950s, which were related to things I could not consciously control.

I grew up in the shadow of the Depression and two World Wars, when there was much to be afraid of. On television I saw grainy images of soldiers under fire in Korea (1950–1953) and Russian tanks rolling into Budapest. I learned in school that New York City was a major target for nuclear attack by the Soviet Union. The outer walls of many big apartment and office buildings bore yellow and

black signs designating them as fallout shelters, and some people stockpiled water and basic foods. During air raid drills, teachers would tell us to crouch under our wooden desks and avert our eyes from the windows, to avoid being blinded by the light of an exploding nuclear bomb. I knew about the bomb's gruesome effects because of news about the 1945 bombing of Hiroshima and Nagasaki.

One day our teachers distributed gray metal dog tags, like those issued to soldiers, to identify our bodies should they be unrecognizable after an explosion. For a year or so I wore mine under my blouse and felt a shudder of fear whenever I became aware of the metal against my chest.

I don't recall learning about the Nazi era and didn't understand its full horror until the early 1960s, when the Eichmann trial was in the news. But I must have heard enough to have had an inkling about the identity of a group of shy older people at a Catskills bungalow colony where we stayed in the mid-1950s. Other adults treated them gently and referred to them as "the refs."

I was aware of death, because my father would often say, half-jokingly, "You're a long time dead," and sing about bodily disintegration. "The worms crawl in, the worms crawl out, they crawl in your nose and out of your mouth." I learned that cancer was a dread disease because, at breakfast, he would scrape the blackened surface off burnt toast to remove what he called "carcinogens." When I was seven, I saw a film in school that depicted rogue cells as tiny red lights reproducing and racing through the bloodstream, twisting and turning along the body's interior corridors.

Death from cancer became real to me when I was not yet nine. On a cold gray winter day, my brothers and I waited in a car parked

next to Montefiore Hospital in the Bronx, while my parents visited my grandmother Eva. My mother had said that we could not come with her to the hospital, because children were vulnerable to infection.

When she returned, she pointed to a high, distant window where Grandma stood, hoping to see my brothers and me. I waved to her, imagining a tiny, shadowed figure by a curtain. On a January morning in 1951, as I sat on the living room floor by the glass-fronted oak bookcase, my father, the emotional parent, whispered gently to me that Grandma had died the night before.

Later I identified with Marie Curie, whose biography I had read. Like Eva, she had been born in Russian Poland and lived in France. Moreover, Eva had had cobalt radiation treatments, and Madame Curie had died from the effects of pioneering experiments with radiation. My mother suffered pains from uterine fibroids and endometriosis and, in 1955, when I was thirteen, had a hysterectomy. She never talked to me about menopause or revealed that she had refused hormone replacement because her mother had taken estrogen and died of uterine cancer.

I used to reassure myself that I was too young to get cancer, but I knew children my age who were afflicted with polio (the epidemic peaked in 1952). A classmate died, and twin girls in school struggled up and down the stairs in leg braces. Posters showed the chilling image of a child living in an iron lung.

And I worried about what I ate, because my father was a tyrant about food. Though he was a salesman who deliberately exaggerated his products' merits, he could be gullible and accept authoritative-sounding claims. He was what in the 1950s was known as a

Carole Turbin, *Furnace*, 2011. Lithograph on paper.

"health nut." He listened to Carlton Fredericks' radio program on nutrition and read the magazine Prevention. He insisted that my brothers and I eat the tough crusts of dark rye bread to strengthen our teeth and jaws, and the skins of baked potatoes, because "all the vitamins are in the peels." To improve digestion, we had to chew each mouthful thoroughly. In school we learned that milk strengthened children's bones, but my father insisted that milk was for calves, not people.

Fifty years later, some of his edicts don't seem so nutty. To alleviate his lower back pain, he went to a chiropractor. He would warn of the danger of cholesterol in red meat and dairy products, and nag us to top our bowl of Rice Krispies with a sliced banana and plain low-fat yogurt, sprinkled with wheat germ. He forbade soft drinks and white bread, because refined flour and sugar lack nutritional value. Every Saturday my brothers and I walked eagerly to the local candy store to buy the one bar we were allowed each week. Vegetarianism was his religion. He often preached, "The stomach is a graveyard for dead animals."

I enjoyed most of what he insisted we eat, including potato peels and the dense rye bread he brought home from the Lower East Side. I happily ate bread with meals, as he badgered us to do in order to "fill our stomachs" and consume less costly meat, the way he had as a child. When I was hungry between meals I would munch on an apple or a chunk of cheddar cheese. A summer snack was a succulent peach picked from the trees my father had planted, or a slice of one of his garden tomatoes sprinkled with salt. On Sunday evenings, my mother's day off from cooking, we went to one of three local restaurants for pizza or what my father termed "chinks," chow mein

and chop suey with crisp fried noodles. After an afternoon performance at Radio City Music Hall or a Broadway show such as My Fair Lady, we would eat dinner at the Horn and Hardart Automat. He directed us to order the vegetarian plate, which I loved: savory baked beans, creamed spinach, and macaroni and cheese.

But he rarely practiced what he preached. He didn't object when my mother served my brothers and me milk at a meal. At Coney Island, he would buy us pink cotton candy. He enjoyed crullers or sweet, flakey apple turnovers sprinkled with powdery sugar with his mid-morning coffee. He loved sausage and hot dogs with sauerkraut and pickle relish, especially the kind sold from carts on Manhattan street corners. Once I asked him why, if he was a vegetarian, he ate meat. He replied that, when he came home hungry from work, he couldn't resist Mom's pot roast. And besides, I should do as he said, not as he did.

Yet he could be harsh. When he found a loaf of Silvercup in the kitchen breadbox, he cursed angrily and tossed it into the trash. One weekday evening I decided to make peanut brittle, which I had learned to do in Home Economics. I loved to cook. The house was quiet; perhaps my mother was playing mahjong with neighbors and my brothers were in the schoolyard. As I stood at the stove, carefully tipping the frying pan to spread the caramelizing white sugar before it burned, my father appeared in the kitchen. "Sugar is poison!" he sputtered. He grabbed the pan from my hand, scraped the confection into the trashcan, and returned to the basement. Angry and deflated, I said nothing and fled to my room.

I had learned to evade his anger by silence. When I was a young child, he would occasionally approach me as I played on the floor,

take off his leather belt, and threaten me by saying, "This is for nothing. You'll get more for doing something." I felt a shiver of dread, though he never actually hit me with his belt. One summer afternoon as he rowed my mother, brothers, and me in a boat in a tiny lake in Kissena Park, I worried that we would capsize. He began to shake the boat, which I knew he was doing to provoke my fears. I understood that the only way to get him to quit was to not allow my fears to show.

Sometimes I rebelled against my father's demand that I finish every scrap on my plate because the children in Europe were starving. When I was five or six, at the end of a meal I would refuse to swallow the last morsel, usually a rye bread crust, which he insisted was especially nutritious. He became infuriated and shouted at me to finish. In the recesses of my mind, I was conscious that I could easily eat the last bit, but my mouth was dry and my throat constricted. When I refused to submit, he spanked me. Once he did this in front of a guest—probably one of his cousins—who objected. My father replied that he and I had an agreement. I also saw it this way. I could avoid being spanked if I wanted to swallow the food, but I chose not to. Though I felt humiliated when he told me to bend down to be spanked, I quietly accepted the penalty.

At breakfast he seemed not to notice what we ate, probably because he was so preoccupied with getting to work. I hated the sour taste of yogurt and the texture of wheat germ, so I simply refused to put them on my Wheaties or Rice Krispies. I silently declined to swallow dietary supplements, which he insisted were necessary for health because modern processed food was stripped of essential nu-

trients. He combined business with his convictions and became a salesman for Nutrilite capsules and pills, which contained dehydrated alfalfa, parsley, and watercress, not synthetic ingredients like other vitamins. They arrived in sturdy plastic containers colored green to suggest nature, had a pungent odor, and were so large that they stuck in my throat. After he died, I found he had squirreled away dozens of these green containers, some packed with paper clips, rubber bands, and the decals and thermometers that he used to glue onto his souvenirs.

His tyranny extended to elimination. Since he had read that our bodies absorb toxins from waste accumulating in our intestines, he had high-colonic irrigations to cleanse his plumbing. Each morning he ate stewed prunes and drank hot water with freshly squeezed lemon juice. He advocated fasting but never did; he was too fond of eating. My mother dealt with his tyranny by ignoring it, as she did his decrees about driving or cutting her hair short. She served meat for dinner and often sent us to school with peanut-butter-and-jelly on white bread. Behind his back she derided his ideas about fasting, but once she made a joke of it. She told me to go to the basement, where he was working, give him an empty bowl, and tell him that it was dinner: a bowl of air.

Though I rebelled against some edicts, I had internalized his decrees about plumbing. I feared the poisons in my own intestines, which my father vividly described. I worried when I was unable to regularly eliminate my bodily wastes, and was anxious about being unable to control what went on inside me. When I told my parents I was constipated, my father would advocate, and sometimes administer, enemas to flush out toxins. Because I had difficulties with

Carole Turbin, *Basement Plumbing*, 2011. Lithograph on paper.

elimination so often, my mother took me to a doctor, who prescribed stool softeners and a high fiber diet.

My father also worried that we stuttered, though my brothers and I don't recall that we did. He probably heard our childish hesitations in responding to his rapid-fire speech, in which there were no moments for a listener to reply, as stuttering. Since I anticipated not being heard, I would struggle to transform my thoughts into

words, pause, and omit details. He insisted that I attend a weekly class at school for students with speech problems; I enjoyed the break in routine and liked the teacher. If my brothers or I spoke quickly or did not "enunciate," he would invoke Coué's theory of reiteration and insist that we sit at the dining room table and fill a notebook with "I shall speak slowly and clearly at all times" and "Every day in every way I am getting better and better."

He also got upset when he saw me reading for hours at a time, because he believed that my vision would be damaged. "Boys don't make passes at girls who wear glasses." He became especially enraged if he discovered me reading in dim light, like under my bed covers with a flashlight, which I did if I had to go to bed when I was not sleepy, on a summer evening before sundown or when he had ordered me to take an afternoon nap. He often maintained that naps were essential for good health. When I was in the third grade, his fears were confirmed; my teacher sent me home with a note informing my parents that I was nearsighted.

My father was convinced by Dr. Harold M. Peppard's book, *Sight Without Glasses*, that eyeglasses worsened nearsightedness by weakening eye muscles. On a few Sunday afternoons, he took me to Dr. Peppard's Manhattan office, which my mother complained under her breath was a waste of money. Daily, I would "palm," soothe my eyes by covering them with my hands for a few moments and do eye-strengthening exercises. Standing several yards from an eye chart pinned to a dining room wall, I would read the letters out loud, first with one eye closed and then with the other. Every few days I moved a foot or two farther away from the chart.

The exercises sharpened my memory but not my vision. Like

My father's prized books and bronze-plated bookends.
Photograph by the author.

my father, who had hidden his poor eyesight, I memorized the chart and could recite the tiniest row of letters, though I still couldn't see them from a distance.

As with elimination, my mother took matters into her own hands and had me fitted for glasses at the Manhattan Eye, Ear, and Throat Clinic. I chose clear plastic frames designed to be inconspicuous. My father would have been furious if he knew, so I wore them only in

school and kept them in my desk at night and on weekends. At the movies I sat in the front row, as he did, due to poor vision. In 1955, when frames became more stylish and movie stars like Grace Kelly sported sunglasses, I wore cat's eye frames of marbleized pink plastic. They went well with my white blouse, turquoise blue skirt decorated with poodles over a puffy crinoline, and white crew socks and saddle shoes. At that point my mother decided that I should go public and pretend to my father that they were my first pair. He said nothing, but I'm certain he saw through my performance.

Beneath all this anxiety, I feared that my father would disappear, as had happened to some things in our household. One day when I was four or five, Lulu, our black cat with white paws, wandered off and did not return. "Where did she go?" I pleaded. My mother didn't know. When my father brought home imports from India, my mother would watch silently as he proudly placed a shiny brass teapot or a carved wooden statuette on the buffet in the dining room. She wouldn't say a word, but a few weeks later it was gone, though he did not notice; he rarely paid attention to his physical surroundings. When I asked where it was, she would say she had "disappeared it." I understood that this was one way she avoided my father's wrath. If she had openly declared that she disliked it so much that she didn't want it in her dining room, he would have become enraged that she didn't appreciate his gift.

Yet sometimes when my mother responded passively to my father, he became even more furious. Their fights usually began in the kitchen. Like most men of his generation, my father didn't do housework, but when Aunt Lil, Uncle Sam, and my cousins visited for Thanksgiving dinner, he would wash the dishes piled up in the sink.

He had a system. First he opened the metal cabinet door bene
the kitchen sink and put a dining room chair in front of it. Then he
would sit on the chair, extending his long legs into the cabinet, next
to the plumbing. When we ate as a family, my mother washed the
dishes, but she always stood. He often urged her to sit, because her
doctor said that standing exacerbated her varicose veins. He would
repeat this several times in his rapid-fire manner while she continued
rinsing dishes and gazing out the window, not meeting his eyes.
Eventually his advice escalated into unrestrained fury.

After one of these fights, he frequently strode out of the house
and slammed the front door. For me his absence was both a relief
and a loss. My mother must have felt lonely, for many times she in-
vited me to share her bed at night. It was a privilege to be in my
parents' bedroom, which was normally forbidden to my brothers
and me. I was comforted by her need for me. Her warm body and
soft voice, complaining of her unhappiness with my father, filled the
emptiness his absence left in me. One day after such a night, as she
removed baked potatoes from the oven, I asked where Dad had gone
and whether he would return. As she looked down at what she was
doing, not at me, she replied that he was at a "Y" and would come
back because "he has a good deal here." After a few days he always
did return but said nothing to my brothers and me about his ab-
sence. I concluded that my parents had no enduring bond with each
other. Nor did they have one with me. I didn't consider their rela-
tions with my brothers.

At other times he stayed away for a week or two; I didn't know
why. Years later I learned that he took solo vacations at nudist
camps. During one of these absences, when I was seven or eight,

my mother silently handed me a postcard from an unknown woman. Alone in my bedroom, I read that she hoped to meet me because my father had praised my artistic talents. When I was older and knew that my father had other women, I supposed that the writer hoped to attract him by flattering me. I wondered if she knew that he had a wife. What did my mother know about her? I'll never know the answers.

Since I was afraid that, at any moment, my father would vanish from my life, I vigilantly kept track of his whereabouts. I barely noticed my mother; she was always somewhere in the house. I would listen for him working on souvenirs in the basement and notice when he sat at the dining room table, adding up numbers for his accounts. I whispered and tiptoed when he was in bed, taking a nap or recovering from back pains. I knew when he was outdoors, raking leaves, installing storm windows, putting up screens, pulling weeds in his garden, or hand-mowing the lawn. On outings, sitting beside him on the LIRR or a subway car or walking with him in Manhattan, I would keep him in view. I feared that he would disappear if I relaxed my vigilance even for a second.

When I was about nine, these fears were realized, but not as I had anticipated; he vanished emotionally rather than physically. Before he bought a car, he sometimes borrowed one from a cousin for the weekend, so we could go to the beach at Sea Cliff in Nassau County. I loved the drive on the narrow road that curved downhill to Long Island Sound, past small frame houses with pretty gingerbread trim. As my mother spread a blanket on the sand, I raced my brothers to the sea. My mother, a strong swimmer, practiced the crawl. My father took a nap. When he woke, sunburned, he took

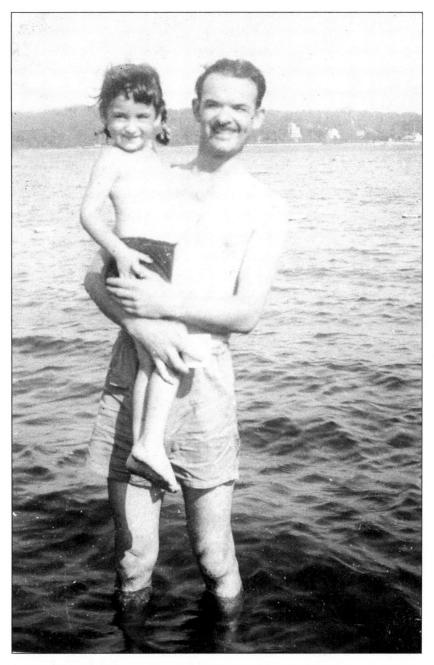

The beach at Sea Cliff, Long Island, in 1951

my brothers and me for a walk to dig for clams. One day at Sea Cliff, as my brothers and I created sand edifices, he approached a girl about my age, playing alone. My heart sank as I watched him chat with her as they built sand castles. On the way home, seated in the back of the car with my brothers, I heard him tell my mother the girl's name and point out where she lived. My throat burned, and my stomach knotted up, because I felt that she was more important to him than I was. It never occurred to me to tell anyone of my feelings.

This incident was the beginning of my father's emotional withdrawal from me. He no longer took me to the Macy's Day parade, to visit my grandparents, or to the circus on my birthday. I said nothing; I was afraid of him. Years later, I wondered whether his withdrawal had been triggered by my first sexual awakening. The year that my birthday came and went without going to the circus, he took me to a film, The Greatest Show on Earth, because, he said, he knew I loved the circus. As young as I was—a few months short of eleven—as I watched the hot romance between scantily clad Betty Hutton and darkly handsome Cornel Wilde, I felt a frisson of sexuality. Perhaps my father, alone with me in a darkened movie theater, felt uneasy with his own sensual feelings. I'll never know, but perhaps he managed his discomfort by distancing himself from me.

At the time, I was furious, because I was certain that now he favored my brothers. Proof of this came one Sunday afternoon shortly after the incident at the beach. My father, mother, brothers and I were sitting in the balcony of a Manhattan theater, listening to a master of ceremonies welcome new Nutrilite commission salesmen. When my father's name was called, he rose from his seat and, stam-

mering and nodding obsequiously as he sometimes did, introduced Richard and Ronald, his identical twin sons born on Christmas Day. He said nothing about me. I felt invisible to him and my mother, silently seated beside me. So I watched enviously as he paid more attention to my brothers, occasionally taking them to a movie or the gym in the St. George Hotel in Brooklyn Heights. I was sure that he preferred them because they were boys and loved sports, a strictly male realm.

Writing this memoir, I began to realize that my brothers had had their own problems. To emphasize their individuality, their teachers had advised my mother to dress them differently and place them in different classes in the same grade. In spite of this, other children would often call them both "Twinny" and my grandfather Sam called them both "Randolph." On Christmas Day, some people gave one gift to share between them for both their birthday and the holiday. I didn't understand that they also must have felt invisible at times.

I had resented them for years. Until I was four or five, I proudly pushed their double carriage about, as my mother did. But as I grew older, I became jealous, because they attracted attention simply by looking so much alike that only my mother and I could tell them apart from a distance. When neighbors passed my mother and me, as she wheeled my brothers' double carriage, they stopped to exclaim how they couldn't tell which handsome boy was Richie, and which Ronnie.

At first, when we fought physically, I could tackle both of them. I failed to anticipate that they would soon grow bigger and stronger than me, and that I was outnumbered. And they were a two-person

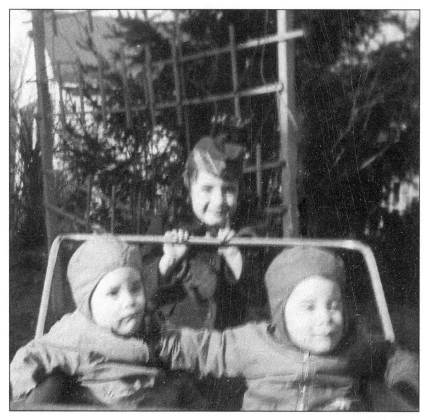

The double carriage with Rich (left) and Ron (right), in the 1940s

world unto themselves, with their own private language. Occasionally one of them would confide in me after bickering with his twin, raising my hopes for an intimate ally in the family. I was invariably disappointed. Soon he would again be whispering to his brother. I tried to divide and conquer by inciting conflicts between them, but they quickly caught on.

Sometimes our squabbles escalated into loud insults and physical assaults, including hurling heavy objects at each other. My mother would appear and intervene only when one of us was bruised or bleeding. When my father heard us fighting, he appeared at the

scene and blamed me, because I was older and should know better. My brothers agreed. I was like him: too emotional, quick to anger. Furious, I silently retreated to my room.

I also resented the fact that, by the time I was ten or eleven, I was excluded from boys' rough, athletic games. When I was younger I played with my brothers, male cousins, and neighborhood boys and, to my mother's dismay, muddied my clothes and scratched my knees by climbing trees. I had learned to run like a boy and always won girls' races, because the others waved their arms from side to side, their bodies swaying. I identified with my favorite comic strip character, Little Lulu, whose body was a red triangle with legs sticking out below. She had also played with boys but one day stood in front of the plank walls of the boys' clubhouse, frowning at the words, No girls allowed.

Years later, when I was no longer angry with my father, I realized that he had tried to reach out to me, just as when he followed me up to my room to apologize after an angry outburst. I must have been about eleven when he took me to Manhattan on a cool, overcast spring day—perhaps my birthday. We walked uptown on Broadway to Columbus Circle and east on 59th Street, beside Central Park. He asked if I wanted to have lunch at Child's restaurant, as we sometimes did on such occasions. "No." As we passed horse-drawn carriages waiting for passengers, he offered me a ride. I would have loved a ride; it was a special, expensive treat. But I was disappointed and angry over his withdrawal and attention to my brothers, and could not find the words to tell him this. So I said, "No." I had retreated emotionally myself and retaliated by refusing to allow him to do anything to please me. That was the last time he

took me on an excursion.

For many years, whenever I passed horse-drawn carriages in the park, I recalled that day, and my stomach churned with regret that I had refused this offer. It was only after my father died that I realized how unforgiving I had been, how incapable of trying to heal the rupture, and how much I loved him.

I suspect that my mother's disdain of him fueled my anger. She and I had become allies and companions. She had no close friends nearby. A childhood friend now lived in Florida, and Lil had moved near Bridgeport, Connecticut, which seemed far from Queens. Their phone calls were brief and practical; out-of-state rates were high, and to them the phone was for conveying information, not for long, confidential conversations.

Now it was my mother who took me on excursions. She introduced me to the ballet. We used to climb stairs to cheap balcony seats at City Center, where I was riveted by Jacques D'Amboise in *Pas de Deux*—and Maria Tallchief in Stravinsky's *Firebird Suite*. Often we shopped at Bloomingdale's in Fresh Meadows and Gertz's Department store near Main Street. Afterward, as we sipped black-and-white sodas at Woolworth's lunch counter, she talked and I listened. Her father was authoritarian. Her mother wasn't affectionate and neglected housework. Sometimes she had taken it upon herself to dust and put things away. She regretted that her parents hadn't pushed her to finish high school at night and go to college. My father was a disappointment.

I began to see him through her eyes. She revealed that he and I did not have the same birthday month, as I had thought. His mother, Pauline, had insisted that, when she gave birth to him, she

heard Memorial Day parades, but his birth certificate was dated July 6. I was disappointed because I felt that being born the same month was a bond between us. I was repulsed when he chewed food noisily and tucked wads of chewed meat gristle under the rim of his plate. Since he'd had had no dental care as a child, his decaying teeth had been pulled out, and he wore dentures. On trips to Radio City Music Hall, I resented him impatiently walking a half block ahead, while my mother, brothers, and I struggled to keep up. My mother complained that he refused to give her money to replace the worn furniture and rug they had brought from Inwood. I could tell that he didn't notice or didn't care that she had discarded the threadbare rug, revealing a bare, scuffed wooden floor, or that the used sectional sofa she agreed to accept from a wealthier relative was a drab beige and too large for the room.

I disdained him and his cheap souvenirs. One day, strolling on 6th Avenue in Greenwich Village, he proudly pointed to Statue of Liberty models displayed in Woolworth's. I gestured dismissively. As he had rejected me, I rejected him.

By twelve, I was more aware of my bodily changes, and my own and my father's sexuality. In the past I had been offended by his pranks. When relatives visited on Sunday afternoon, he would laugh at their dismay when a mechanism held in his palm as he shook hands made a fart-like sound, or as they spotted plastic vomit where they were about to sit. Now I noticed his openly sexual behavior at family gatherings. That year, my four male cousins turned thirteen and had bar mitzvahs, which in my left-leaning family were not religious observances but secular birthday parties. (Bas mitzvahs for girls were unheard of.) My father would drink one shot of whiskey

ter another and flirt with a woman he hadn't met before, like an in-law's sister or wife, while my mother chatted with a relative in another part of the room. Afterward he would drive home drunk but safely, as people did in those days.

I felt embarrassed and self-conscious when we had dinner guests and he dominated the conversation with sexy jokes: "Girls who don't repulse men's advances advance men's pulses."

"Liquor: A thing that one drinks to make one see double but feel single."

"Do you know what happened to the sex- crazy mouse? The pussy got him."

After the meal he would raise a glass and propose a toast. I would avert my eyes, pretend I did not notice, and inwardly cringe, as he declaimed,

> *Here's to you so sweet and good;*
> *God made you; I wish I could.*

One day I gathered courage and told him that his racy anecdotes and toasts made me uncomfortable. He dismissed my distress. People enjoyed his jokes. Did I want to deprive our guests of pleasure?

By the time I was fourteen or fifteen, I felt repelled by him. He rarely kissed my mother or me, but now when he did he aimed at my lips; I would deftly turn away so that his lips landed on my cheek. I protected myself from whatever sexuality he had toward me, or what I had toward him, by transforming my mix of anger and love into revulsion. I felt shy with other men in my family and ill at ease with boys I was attracted to at school.

Meals became even more of a battleground. Once my father became so enraged—I don't recall why—that he pounded his fist on the kitchen table so hard that the leaf broke off. He fled to the basement, and my mother, brothers, and I continued eating in silence.

To avoid battles my mother served dinner to us and my father separately. Since my brothers and I bickered at meals—when I objected to the way they slurped their food, they ate all the more noisily—my mother served me in the dining room and them in the kitchen. My father had his meal later, in the dining room; I didn't notice when my mother ate. I swallowed my roasted meat, baked potato, and defrosted, boiled green beans quickly, to satisfy my hunger, and then went to my room.

Fights between my father and me escalated. He would draw me into arguments by asking what I thought of one of his pet ideas, knowing, it seemed to me, that I would disagree. If I did, he flew into a rage. My mother noticed his attraction to locking horns with me and remarked that "those arguments" were "his bread and butter." I believe that his anger was not only a means to dominate and control others but also to satisfy his desire for drama, intensity, and emotional connection. I was drawn into the battle for the same reason. Deep down, I adored him all the more because his fearsome anger was open and direct, unlike my mother's coolness and passivity. His rages were moments when an adult was truly present. Through antagonism, I could experience my intense emotional connection with my father and at the same time maintain my distance.

This was the state of my relationship with him in September 1957, when I started attending Bayside High School, a brick building on Corporal Kennedy Boulevard, built by the WPA in 1936. In

many ways I was typical of students in the Academic track. I was a grandchild of Jewish immigrants, taking honor classes in English, history, science, and art. I listened to the Four Lads, Dean Martin, and Bill Haley and the Comets on a yellow plastic portable transistor radio. I danced the Lindy. I stood in line with a friend to see Elvis Presley in *Love Me Tender* at the RKO Keith palace near Main Street. I cheered at the final Giant–Dodger game in New York. I watched *Gunsmoke*, *I Love Lucy*, and *General Electric Theater*, which began with Ronald Reagan saying, "Progress is our most important product."

Still, I felt like a misfit. I detested female frills, flowery patterns, and girls who teased their hair. I was taller than all but a few boys at school and thin, too thin, like my father. My mother bought me padded bras and occasionally gave me money for a milkshake at the soda shop.

After a year or so, I befriended other shy misfits who were not "girly." They introduced me to recordings of Handel's Messiah, cheap standing-room tickets to the Metropolitan Opera, and the Cloisters Museum. I had never heard of it, though I had been born only a few blocks away. We read serious books: Irving Stone's *Clarence Darrow for the Defense*, John Hersey's *The Wall*, Franz Werfel's *Forty Days of Musa Dagh*, and Theodore Dreiser's *American Tragedy*. I joined the school art club. I adored theater. The family of a new friend had taken me to Shakespeare and summer stock productions. For a time I wanted to be a stage set designer. I envied my friends' parents, who calmly talked about ideas and world events at meals as we sipped coffee from delicate white porcelain cups.

I had already glimpsed this refined, cultured world when we vis-

ited my mother's parents. I adored Nathan. When I was a child, after dinner he gave me piggy-back rides, crawling on his hands and knees. On visits to Auburndale in the 1950s, after Eva died, he arrived with the makings of dinner—a chicken, feet and all, in a plastic bag. Tucked under his arm were the *Forward* and the *New York Times*, which I knew was superior to my father's *Daily News* and the *Long Island Star-Journal* that was delivered to our front door each morning. After removing his jacket and shirt, Nathan talked as he sipped coffee in the dining room in a paint-speckled undershirt. I listened. He spoke Polish, English, French, and Yiddish, and no one could keep secrets from him in German. He attended lectures at Cooper Union on Astor Place and browsed in second-hand bookstores on 4th Avenue. When he asked what color I wanted him to paint my bedroom, I asked for white. He replied, approvingly, that I was a bohemian; I hadn't chosen popular colors, gray or light green. Next year he gave me two volumes of Voltaire and, for my birthday, a Modigliani print.

I admired Uncle Harold and his wife, Aunt Jean, a children's book author. Their sophisticated home had a contemporary slingback chair, rows of books on shelves, and modern art on the walls. Harold played the recorder and occasionally visited our house to accompany my mother on the piano. When I was sixteen, he painted my portrait, which now hangs in my home. I had learned to draw in charcoal and pastel and use oil paints in a private art class. Now I learned to pose as he gazed at me, drew a sketch in charcoal, dipped a brush in color, and applied it to the canvas.

As my world expanded, my alliance with my mother crumbled. In a biology course I wrote a paper, complete with footnotes and a

Hal Fiedler, *Carole*, 1961. Oil paint on canvas.

bibliography, about a frightening subject—the medical use of radiation. I argued that it destroys cancer cells for the same reason that it is dangerous to children: It targets growing cells. I received an "A" and imagined that, one day, I would become a researcher and writer. After dinner in the kitchen, I showed the paper to my mother. She turned the pages to the end, her eyes scanning the words as if she were reading it. When I asked her what she thought about something in the paper, she couldn't answer. I realized that she hadn't actually read it and told her so. She admitted that I was right. She hadn't. Then she confessed that Lil had accused her of not listening to her, and she admitted that Lil was right. She said nothing more, and turned to cleaning up after dinner. I felt deflated and disappointed but silently went to my room with the paper.

I was furious. She admitted that she hadn't read the paper I was so proud of and, worse, turned away from me as if I were unimportant, even invisible. And even though she didn't listen to me, she needed me to listen to her. Looking back now, I realize that, for some time, I had felt that her confidences were a burden, not a bond. When she told me that, at my birth, the episiotomy had been excruciatingly painful, inwardly I cringed at the thought of causing her pain, though rationally I knew I wasn't at fault. And she depended on me to make household decisions. Should we continue to be members of the Temple? After several days of shopping with her for new furniture with money she inherited from her father, Nathan, she could not decide. So I pointed to a Danish modern sofa with nubby reddish-brown upholstery, and that was what she bought. Years later, Rich confided that, as he became older and more self-confident, she depended on him, too, as if he were a substitute husband.

In my senior year I found words for my feelings about my mother's indifference in a short story for the English Club. The advisor, Mr. Neiman, who was slim and soft-spoken, with intense brown eyes, invited me home after school to help polish my story. As I sat beside him in his study, he typed suggested revisions on a black office typewriter. The story, "The Long White Envelope," the lead piece in the winter 1959 issue of Soundings, the school literary magazine, was more like my father's tale about a boy's struggle in "Little Billy" than my mother's teenage writing. Faith, a high school senior, envies a friend whose mother is pleased when her daughter reports an accomplishment. When she returns home after school, Faith notices that, as her mother reminds her to wash her milk glass and put away the bottle, her face is disappointed and her voice flat. Then, absently, her mother points to a long, white envelope on the dining room table, containing a rejection letter from the college Faith hoped to attend. Faith looks at her mother and thinks about her friend's mother's expressive face. She picks up her books and goes upstairs to her room.

I felt alone. My parents, despite their problems, had a private relationship that excluded me. My brothers had each other and schoolyard pals. I suspected that they disliked me because I resembled my father, the family villain, in personality and appearance. They were like my mother, controlled, never openly angry. So I ignored them, evaded my mother's confidences about her disappointments, and shunned my father. It didn't occur to me to confide in my friends. I had no experience speaking about my feelings. And how could I explain, when to the outside world my mother appeared sweet, beautiful, and talented, my brothers handsome and popular,

and my father good-looking and entertaining. I had retreated into an inner world and created a psychological wall between my family and myself.

"The Long White Envelope"

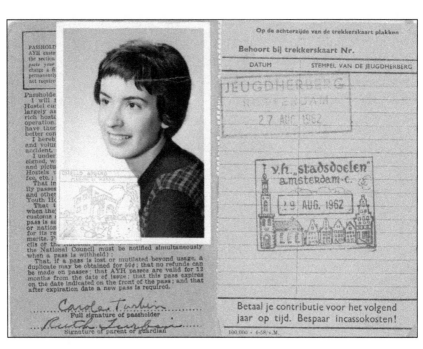

My American Youth Hostel pass, 1962

7.

Escape

I LONGED TO ESCAPE FROM MY FAMILY to college like my arty, intellectual girlfriends who had applied to Brandeis and Syracuse universities. My parents expected me to go to college, and I believed that they could afford tuition. We lived in a house, not an apartment, my father had a job and a business, and my mother gave piano lessons, had beautiful clothes, and went to the ballet.

But she insisted that they couldn't afford an out-of-town school, even if I got a scholarship. I was certain that attending a tuition-free city school would be like high school, and that I'd be miserable living at home. My grandfather Nathan gave me money from his savings for my education, but it was not enough for even a year at an out-of-town school. By then, my father and I were barely acknowledging each other's presence, so it never occurred to me to ask him for help.

If I could not go away, I hoped to attend the most selective city

school, Queens College. Like Faith, I anxiously awaited a long white envelope, but when I returned home from school my mother had already opened it and, in her quiet tone, told me I had been rejected. It said I could go to Hunter College, a girls' school on 68th Street and Park Avenue, or to Queens' evening session, which was open to anyone with an Academic high school diploma.

What to do? Whom to ask for advice? My parents knew nothing about colleges. A school counselor recommended that I attend Queens in the evening and later transfer to the day session. Luckily, I encountered my misfit friend Terry at the guidance office and told her my quandary.

She said, "Ask Leonard."

Leonard Lief was her stepfather, the President of Hunter College in the Bronx (now Lehman College). My heart pounded as I dialed the number, but his voice was kind and firm. At the evening session, I wouldn't feel that I was in college. Hunter was an excellent school. If I preferred Queens, I could transfer there later. That was what I did.

It was exciting to travel to school in midtown Manhattan. I loved my classes, admired my professors, and was exhilarated by the civil rights movement, which was percolating up North from the South. To support the sit-ins at segregated lunch counters, I joined students who picketed Woolworth's on Main Street, Flushing. One day, in solidarity with the sit-ins, we ate our sandwiches in the college cafeteria standing up.

My mother bought me stylish clothes—a slim olive green woolen skirt with a fitted jacket, and high-heeled shoes—and took me to an optometrist for contact lenses, which had just appeared on the mar-

ket. When she hired workmen to build a second bathroom in the basement, I was more certain than ever that she could have paid for an out-of-town college if I had gotten a scholarship. I kept this to myself, for I had learned that I could not convey my feelings to her. She would not have heard me.

In January 1961 I transferred to Queens. There I found a haven in the art department, in a temporary World War II era building with scuffed wooden floors splattered with paint. My artistic forte was figurative drawing, as my father somehow knew that night so long ago, but Abstract Expressionism reigned then in New York's vibrant art scene. Elias Friedensohn taught me to identify abstract shapes in objects and use a brush and color expressively. One semester I was art editor of the student art–literary magazine, which featured one of my charcoal drawings.

In the art studios, girls were permitted to wear dungarees. We changed into a skirt to go to class, the cafeteria, or the library, to avoid being fined by patrolling matrons—*in loco parentis*—for violating the dress code. Even during winter blizzards we wore skirts just below our knees, shoes of fashionably thin leather, and sheer stockings attached to a scratchy garter belt. Girdles were *de rigueur,* to prevent wiggling of rear-end flesh, of which I had precious little.

On November 22, 1963, as I crossed a parking lot to the art studio, I noticed a man listening to his car radio. The President was dead. In the studio, students and faculty were shaken and teary. It did not occur to me to call my parents. Instead, a friend and I took a bus and subway to Greenwich Village, which was the equivalent of our college town. We hung out there in coffee houses filled with cigarette smoke and lively conversation about art, culture, and pol-

Carole Turbin, *Seated Nude*, 1962. Charcoal on paper.

itics. We thought of ourselves as beatniks, like Jack Kerouac and Allen Ginsburg, whom the bolder of my friends had observed at the Cedar Tavern. I frequented the tamer Café Figaro. Now that I was earning money working part-time in the college library, I had bought clothes in the Village that fit my new identity—black turtlenecks, Fred Braun sandals, and a black leather shoulder bag. Without a purse hanging from one arm, I could move my hands freely as I walked. As bohemians, we disdained girls who wore gold circle pins on the rounded Peter Pan collars of pastel cotton blouses. The pins, we joked, represented virginity, which they protected, or so we thought, until their wedding night. My friends would proudly claim that they had "lost" their virginity with a boyfriend or a guy they'd encountered at a party or bar. They understood that most men wouldn't take the initiative to prevent pregnancy, so it was women's responsibility. But birth control was illegal for unmarried women, so some took chances and others went to Margaret Sanger clinic on West 16th Street to obtain a diaphragm, and claimed they were married. Abortion was illegal in New York State until 1970.

Compared to most of my friends, my notions of sex were limited to school biology lessons and stolen glances at my parents' medical guide, which I was forbidden to read. I must have associated sexual organs with toilets in bathrooms, where the pipes had scared me so long ago. So when I discovered a diaphragm in my mother's dresser drawer, I imagined two adults having sex on the bathroom floor. Once I asked my mother if I could use a tampon during menstruation. She said no, that they were for nurses. From that remark, I assumed that vaginal insertion required medical expertise. In sexual encounters, I stopped short of intercourse, worried about becoming

pregnant. And later I realized that, because of fears associated with my own plumbing, I had been afraid of giving my sexual desires free rein.

I yearned to see far-away places, as had my grandfather Nathan, who had lived in Paris and was the first person I knew who'd traveled by plane. On a cold day in 1959 my mother and I, Aunt Lil, and my cousin Barbara had accompanied him to La Guardia Airport, where he boarded a flight to Miami Beach. At a resort for single, older Jewish men and women, he met a widow named Ida and married her a few months later. He moved from his Bronx walk-up to her frame house in a Bridgeport suburb, not far from Lil and Sam's home. On his seventy-ninth birthday, July 10, 1960, at Unity House, the ILGWU resort in the Pocono Mountains, he looked dapper in a gray summer-weight suit.

Less than a year later I visited him in a Bridgeport hospital but had no idea how ill he was. When he was discharged, Sam and Lil moved him to their new split-level home in New Jersey; Sam had been promoted to the ILGWU's New York office. I didn't go with my parents to visit him. I longed for time by myself, and it never occurred to me that I might never see him again.

He died of colon cancer in February 1961, six months before his eightieth birthday. At Garlick's Parkside Chapel in the Bronx, a gray-haired man praised Nathan Fiedler's contribution to the Bund and read a notice in the Forward, which commended him as a "friend of the Workmen's Circle." Since I had not said goodbye, I felt that he, like my father, had disappeared.

About that time, a Queens student I knew from high school mentioned to me that Mr. Neiman, the English teacher who had

Nathan on his 80th birthday, probably at Unity House,
the ILGWU resort in Forest Park, Pennsylvania, in July 1961

helped me write my story, had died suddenly of a heart attack. I had thought of thanking him for encouraging my writing; I had enjoyed and done well in a college creative writing course. But I never had; I was too shy. Now that he was gone I felt that he also had disappeared.

I didn't ask my parents for permission to go to Europe with my friend Suzanne in the summer of 1962. I felt that I was an adult, had saved money for the trip, and was going—and they seemed to accept my plans. Jet plane travel was expensive, so, like most tourists, we planned to cross the ocean by ship and stay overseas for a few months. But we chose our own destinations rather than join a guided tour. Suzanne was almost fluent in French, and I had studied it since seventh grade.

As the *SS Waterman*, a Holland-America Line ship that had transported troops in World War II, departed from a Hudson River pier at the end of May, my parents, brothers, cousins, and friends waved goodbye. I was in high spirits.

But the North Atlantic was stormy and the ship lacked stabilizers. For several days, I was seasick. When I recovered, I enjoyed lectures (Martin Esslin spoke on the Theater of the Absurd) and met tall, worldly-wise young men from outside New York. That such men were attracted to me was a revelation. Ten days later, as the ship docked at Le Havre, I thought about Nathan, who had left France from the same port.

Paris, the first foreign place I had ever visited, was overwhelming. I was determined not to be like American tourists who addressed waiters in English and insisted on home comforts. I spoke schoolgirl French, used newspaper for toilet paper in our hotel's WC,

and carried oranges purchased from an *épicier* in a string bag. I learned the purpose of a bidet. At dinner I ordered mineral water and sipped coffee afterward, not during the meal as my family did. Since European women didn't wear pants, my dungarees remained in my suitcase. I envied Parisian café society, where sophisticated friends met for drinks or a meal and conversed about art and ideas.

Suzanne and I took a train to Chartres, but we missed the last one back to Paris. Thus, we discovered that European students, mostly Swedes, Danes, Germans, and French, traveled by hitchhiking (*autostop*). In postwar Europe, few people owned cars, but those who did would stop for young people exploring the world on a tight budget. To travel lightly, we shipped suitcases with most of our clothing to *poste restante* in our final destination, Amsterdam. In youth hostels, we ate cheap meals, shared bathrooms, and slept in dormitories.

One rule of safe *autostop* was to avoid rides with men, but at the end of June, in Marseilles, we made an exception because it was near sunset. When the young male driver reached a grassy, deserted field on the city's outskirts, we realized that he was not headed for the Auberge de Jeunesse. I, in the front seat, looked at Suzanne anxiously and whispered that she should grab the door handle. He slowed, cajoling us in colloquial French, "*Je veux nique les deux.*" As he reached for my rear end, we jumped out of the car, landing with our bags in the field.

Luckily there was a motel nearby, a rarity in Europe in 1962, when most travelers slept in bright blue tents in campsites by the road. We told the motel owner we were students with little money, and she let us sleep on spare mattresses in a storage room. In the

morning we hitchhiked to Grenoble, where Suzanne was going to take language classes. We arranged to meet again on August 1 at the youth hostel in Barcelona. I had planned to meet a guy I knew from New York in Grenoble and motor scooter with him to Italy. Alas, our ride through the spectacular beauty of the Alps was not a romantic adventure; we had little to say to each other. I was relieved when we parted ways at the youth hostel outside Florence.

At breakfast in the hostel I sat at a long wooden table in a sun-drenched garden rimmed by tall cypress trees. At home I had eaten my mother's plain meals quickly, to satisfy hunger and get away from tensions at the table. Now, for the first time, I lingered over *caffé latte* and fresh crusty bread, and later in the day I savored *gelato*. My youth hostel companions and I gazed at Michelangelo's David and Giotto's frescoes, all in public places, piazzas, and churches, not museums, for passersby to enjoy as they went about their lives. We found the same in Venice, Ravenna, and Rome. Then I hitchhiked with a French woman down the Riviera to Barcelona, where I joined Suzanne.

Back at home after three months of independence, living with my family was intolerable. I was jealous of my brothers, who attended prestigious upstate schools, funded by scholarships. My parents' attitude toward college hadn't changed. But my brothers, both officers of their high school class, had more encouragement and advice from guidance counselors than I had. Using my savings—Europe had cost less than expected—I sublet an apartment for a few months with a Queens College student in Stuyvesant Town, near where my father grew up. I felt alive in the city, though my grades suffered. Since I had to take two subways and a bus to classes, I

was often late. With friends, many of whom I met in Europe, I went to avant-garde events, such as a performance of The Brig at the Living Theater on 14th Street, and quiet, contemplative spaces at the Museum of Modern Art, the Metropolitan Museum, or the 42d Street Library's grand third-floor reading room.

To my relief, standards of female beauty had changed in my favor. Mary Travers, of Peter, Paul, and Mary, popularized long, straight hair with bangs, and a natural look enhanced with eyeliner and red lipstick. Tall and thin were fashionable, personified by Twiggy in 1966. Women were no longer judged by hip, waist, and bust measurements. I wore fashions that I had admired in Paris, a tweed A-line skirt just below my knees, a deep green Italian knit sweater, stacked-heel shoes, and lacy black pantyhose. No more girdles and garter belts. On frosty days, fur-lined boots warmed my toes and calves.

Although I yearned for a safe haven of love, I was attracted to men who were more exciting than dependable. Two creative brothers had been hospitalized for depression. An art history graduate student dropped me when he saw me with a guy I had met in Florence, who also dropped me. A Columbia University psychology graduate student had other girlfriends. An aspiring actor was unreliable. A guy from Utah, who lived on Bleecker Street, was footloose. He was the first man I had sex with, and I often spent the night with him, telling my mother I was with a girlfriend in the Bronx. Sometimes we rose before dawn, took the subway to the Cloisters, and watched the sun rise over the Hudson River. I dropped him when I learned that he had slept with a friend of mine.

One afternoon my mother remarked, it seemed out of nowhere,

When women's fashions changed in my favor.

that I would be more attractive if I had my nose fixed. Without a word, I turned away and took the subway to a friend in the Bronx. Didn't she know me, that I disdained girls who had cosmetic surgery to fit conventional notions of beauty, attract a wealthy husband, and live in a bland suburb? The next day I phoned to let her know where I was. Though I kept my distance from her, she was my mother and the only parent I had a relationship with, since I rarely saw my father and avoided him at family gatherings. In a tight, cool voice, my mother asked what had happened to the money in my savings account. I realized she had searched for my passbook in the desk in my room. Did she suspect that I intended to leave home and disappear? I replied that I had loaned the money to my friend Jeannie for an abortion. She retorted, "Ma and Pa worked hard for that money!" I assured her that my friend would return it. She calmed down, saying at least it wasn't me who needed an abortion.

I rarely encountered my father during these years, but on two occasions his temper erupted into physical violence. One evening in my third semester, Fall 1961, he overheard me yelling at my brothers because one of them had taken from my desk drawer the last sheet of typewriter paper. I needed it to type an essay for class the next day. As always, my father blamed me. I protested that it was their fault, and he raised his arm to strike me. I backed into my room, landed on my rear on my bed, feet in the air, and he followed, his arm still raised. I kicked him in the chest, and he retreated. So did my brothers. My mother was downstairs, silent. Alone in my room, I latched the door, feeling angry, lonely, and humiliated, a feeling that lingered in me for a long time.

The following fall, my father sat across from me during a rare

family dinner in the kitchen dining nook. He pulled a small white box from a side pants pocket and handed it to me. Inside I found a loving gift, a charm bracelet from which dangled tiny souvenirs. Each represented one of my interests: an artist's palette, an ocean-going steamship, a piano, and medallions from Barcelona, Paris, and Italy.

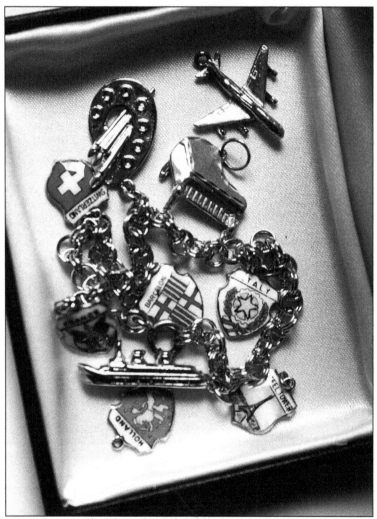

The charm bracelet with tiny souvenirs.
Photograph by the author.

I thanked him coolly. I resented that he did not know that I disliked conventional feminine adornment. I was angry that he had dropped me in favor of my brothers, or so I thought. And I still felt humiliated from his attack the previous year.

His face reddened as he berated me for not appreciating him and not being affectionate. I accused him of appreciating Richie and Ronnie more than me. How did he expect me to appreciate him? He lunged across the table, his arm raised, and I slid away, raced up to my room, and latched the door. He followed and pulled at the doorknob until my mother came upstairs and barred him from entering. It was the first time I recall her interfering in a family fight.

I've often wondered, had I thanked him lovingly for the bracelet, would he have responded affectionately? Perhaps. But I was unforgiving. About fifteen years later, a new friend asked when my father had died. I realized I always spoke of him in the past tense, to wipe him from existence. Yet the charm bracelet remained in my jewelry box, which I carried from one home to another, forgotten until memories of plumbing and the old bond with my father crowded back into my consciousness.

In January 1964, after graduating college, I escaped again. Inspired by Kerouac's On the Road, I paid a hundred dollars for a Greyhound bus ticket to Berkeley, California, to visit a friend who had followed her boyfriend to the university. I yearned to see more of the world and meet tall, sophisticated men like those I had encountered in Europe. My mother was appalled; she said she would have to take tranquillizers to calm her anxieties about me. Long-distance buses were not for young women but for poor people or servicemen on leave. But I was going, financed with savings and my

grandfather's gift. I intended to get a job. . .and then what? Go to art school, I wasn't sure where.

On the front porch, as I departed, my father, stammering, offered me money. I was touched by his generosity and realized that saying goodbye was not easy for him. But I accepted the gift with a brief "thank you" and left the house. Rich drove me in the rattling red station wagon to the Port Authority bus terminal. Years later he reminded me that he had tried to calm my anxieties about leaving by telling jokes. He too had yearned to escape. His fantasy was not like mine, a beatnik "on the road," but a cowboy riding out of "Dodge City" on horseback. And after graduating from Cornell University and Harvard Law School, he did go so far west that he was almost east, to the Peace Corps in Samoa and to Hawaii.

I got on the bus clad in jeans and a black hooded ski jacket, carrying the shoulder bag I had used for hitchhiking in Europe. En route I visited my cousin Barbara in Cleveland, where she had moved with her parents when Sam was promoted to vice president of the ILGWU's Midwest region. Then I went to Chicago to see my friend Eva in graduate school, and to Aspen, Colorado, where another friend was living with a ski bum. When I tried to board a bus from Colorado to California, I discovered that the previous driver had mistakenly torn off the remainder of my cross-country ticket. So I hitched a ride from Aspen with a ski bum, Big John, who was headed to the west coast in his Volkswagen Bug. Snow and ice clogged the tiny windshield as we drove over mountains and through deserts in Nevada and Utah to California, staying in separate hotel rooms. When we crossed the Sierra Nevada Mountains into California's sunshine and lush greenery, I felt that I had arrived

in paradise.

Berkeley was the college town of my dreams, with coffee houses, bookstores, and cheap eateries crowded with students. The pastel Mediterranean-style homes reminded me of the Italian Riviera. San Francisco, which I reached by bus (Bay Area Rapid Transit was barely a gleam in city planners' eyes) across the Bay Bridge, was small compared to New York. From the terminal I walked to North Beach and was thrilled to see Lawrence Ferlinghetti, poet and beatnik, behind the counter at City Lights Bookstore.

Most UC–Berkeley students studied practical subjects such as engineering, medicine, or education, but I found radicals in a Quaker-run cooperative boarding house on Haste Street, which is currently the site of the People's Park. We shared rooms, cooking, and cleaning chores. I found a job as a billing clerk at the Sierra Club, which I first thought was a nightclub. As I departed work at 5:00 p.m., my blonde, frizzy-haired boss from rural California would drawl, "See you tomorrow, if the 'crick' don't rise."

Still I longed for a haven of love. After a few dates and amorous encounters, I met three tall, appealing guys, Bill M., Bill R., and Bill D. Bill Miller chased me and I fell for him. During the Free Speech Movement, in February 1964, we watched Mario Savio speak standing atop a police car. Bill introduced me to Tex-Mex and Szechuan food. I worried that I was attracted to him because his first name was the same as my father's, and that I might be repeating that troubled relationship. But I reasoned that I knew three guys named Bill, and this one's real name was Wilbur. Besides he was totally unlike my father. Born in Iowa City to lapsed New England Congregationalists, he had grown up in Los Angeles. Berkeley was his escape too,

and he also longed for love and security. When he was twelve, his mother had committed suicide and his father, a psychiatrist, had never recovered.

I loved him because he knew who I was. His first gift was arty turquoise jewelry. He loved books, art, and classical music, could whistle tunes from symphonies, and planned to be a professor of

Bill M. and me (top row), with Bill D., Bill R., and friends
in Monterey, California, in July 1964

U.S. history. On our first night together, on a sofa in a house I shared with roommates, we clung to each other. I trusted him not to disappear. At twenty-two, I needed birth control. I was not going to risk leaving it up to him as I had with my footloose boyfriend. A doctor in Berkeley refused to prescribe a diaphragm because I was unmarried, so I went to Planned Parenthood in San Francisco. The receptionist called me "Mrs." (I didn't correct her) and a doctor prescribed pills.

After a year working at the Sierra Club, I wanted to be more than a secretary, though I did not know what that might be. I applied to UC-Berkeley's Fine Arts M.A. program, a center of Bay Area figurative painting, not because I wanted to be a professional artist but because art was what I knew and did well. I qualified for in-state tuition, which I paid for with part-time work at the Sierra Club, my savings, and a low-interest, federally guaranteed student loan. And I read Betty Friedan's The Feminine Mystique. Then I understood why I had rejected the bland suburban life my mother wanted for me. And I was not unique. Though I was on my way to a Fine Art M.A, I still wasn't sure what I wanted.

Looking back now, I realize that, although I had forgotten how drawing the angled pipes in shadows beneath the old sink had soothed my childish nighttime fears, I became committed to an art career when I understood that my best work conveyed something deep within me. My most successful painting was of semi-tropical foliage, which I'd never seen before. I loved pink bougainvillea blossoms and towering palm trees, but I was wary of fleshy succulents, especially those resembling giant scaly pineapples. At times, when I passed one as I walked along a sidewalk, I cringed for a moment,

Carole Turbin, *California*, 1965. Oil on canvas.

imagining that the broad, spiky green leaves were reaching menacingly toward me. So I did a painting of vivid, looming foliage with finger-like ends in bright yellow California sunshine.

Even though our ideas about the future were vague, in May 1965 Bill and I decided to marry. In those years, most young people wed in their early twenties, and living together was unusual even among our unconventional friends. I wanted to be married in New York by a rabbi, not in an impersonal city hall ceremony. So I called my mother, though we rarely spoke by phone (long distance calls were expensive) and had exchanged only a few letters. She was relieved that she would meet him. When I told her that he wasn't Jewish, she said, "At least he isn't a Catholic."

To drive cross-country, we bought a dark blue 1958 Volvo with tiny rear lights. Foreign cars were so rare that, when we passed one on Route 66 (Interstate 80 was incomplete), the driver honked at us. We stayed in campgrounds, sleeping in the car, whose seats folded into a bed. In Cleveland, our last night on the road, Bill met Aunt Lil and Uncle Sam. As we drove off, Lil phoned my mother to assure her that Bill was an acceptable son-in-law.

We arrived in Auburndale in mid-June at about 1:00 a.m. My mother forbade us to stay in the same room, so Bill slept on the front porch. His first impression of my father was that he talked like Sluggo from Nancy comics. Much remained unsaid between my mother and me, but we planned a wedding. She located a rabbi who was willing to marry a mixed couple—rare in those days—and arranged for a backyard reception. To ensure a high tone, she asked neighbors not to hang their laundry outside to dry. She gave us Revere Ware pots and stainless steel tableware, which she acquired by

redeeming box tops from laundry soap. We also received generous checks, which we lived on for a year.

My family welcomed Bill. He often says he was dazed when my aunts—Bertha, Marian, Mollye, Selma, and Brita—approached him en masse and kissed him. In his family, even close relatives shook hands. My grandmother Pauline, eighty-two, was impressed by his gray-haired father, Dr. Wilbur Miller, Sr., from Cape Cod. For years she talked about how he treated a guest's injured finger with band-

Our wedding reception on June 20, 1965

ages from his black leather satchel. A few weeks after we returned to Berkeley, a package arrived: a box of her homemade apple strudel.

I wanted security but not marriage's conventional trappings. Since white signified virginity, I wore a turquoise blue knit dress. The rabbi, whom I had never met, assumed that my cousin Barbara, the maid of honor, was the bride because she wore beige. I snatched the miniature plastic bride and groom off the top of the wedding cake. And I recruited my cousin Dave to sit on the front steps to stop guests from decorating our Volvo with signs saying Just Married.

I hoped to remain in Berkeley, where I was part of a community of artists, students of California realists Elmer Bischoff and Richard Diebenkorn. So did Bill. But Cal's history faculty did not admit graduates of their own department. He had a Woodrow Wilson Fellowship, which he could use at any of the graduate schools that had accepted him—Yale, University of Chicago, and Columbia. I lobbied for Columbia because of New York's art scene and my friends. It did not occur to me to remain in Berkeley to complete my M.A. Commuting marriages were rare, and Bill and I depended on each other. My fear that a man I cared about would disappear, never to return, lurked beneath my awareness and occasionally surfaced when Bill and I were temporarily apart. To this day, once in a great while that fear returns. Luckily for our relationship, Bill chose Columbia for his own reason, the opportunity to study the newly emerging field of Social History.

In August 1966, we packed up the Volvo and drove east via the Trans-Canada Highway. Apartments near Columbia were too ex-

pensive, so we rented a cheap fifth floor walk-up in Inwood, a few subway stops uptown from Columbia. I thought of it as an economical choice, not a return to my birthplace, as I felt no relationship to the neighborhood. I worked part-time as a typist for the Ethical Culture Society and shared a loft studio with other artists in a former garment factory near Broome and Greene Streets. My plan was to do paintings for my degree in New York, finish coursework in Berkeley during the following summer, and submit the artwork for the MA degree in the fall. Then I would apply for a job teaching art in a two-year college.

We had less money than other graduate students in Bill's department because most were men who lived on their fellowships and their wives' earnings as schoolteachers, social workers, or secretaries. I was the only wife who expected to have a life-long career. The others intended to quit work to have children when their husbands got jobs. My mother expected me to do the same and regularly informed me when she heard of a full-time office job that was available. At dinner parties, the women chatted in the kitchen after the meal about recipes and babies, and men discussed politics and ideas in the living room. I felt again like Little Lulu, standing outside the boys' clubhouse and staring at the words scrawled on the wall: No girls allowed.

I was no longer sure that I wanted to be an artist. I hated the current trend, huge Pop and Op spray-painted canvases. I prized careful drawing at a time when it was not valued for itself but for composing oil paintings. I had forgotten the vision that enabled me to tap into my deepest feelings in my artwork in California.

One day, feeling dissatisfied with the painting I was working on,

I realized I was more engrossed by politics—the civil rights, anti-war, and student movements—than my artwork. When I read in Ramparts magazine about feminist demonstrations at the Atlantic City Miss America Pageant, I was convinced that this was my movement. I too had measured myself by unattainable standards of beauty, worn a scratchy garter belt, and squeezed into a girdle.

Still, I was determined to complete my M.A. The following summer we drove cross-country to Berkeley. I took art courses while Bill pumped gas at a Standard Oil station in Oakland. He had to shave his beard and sideburns, and wear a clean white uniform each day. Back in New York, I shipped my paintings to Berkeley to be evaluated. They were rejected. The art world had shifted, and California realism had waned. My teachers were on leave, and their replacements, a sculptor and minimalist painter, were strangers to me and my work. I submitted a second time. As I read the second rejection letter, my stomach churned. Who was I? What should I do next? I wanted to earn a living, but without an M.A. I couldn't get a job teaching college art. I didn't want to teach high school. My desire to be an artist had faded. I was anxious, lost my appetite, and had painful back spasms that kept me in bed for a few days, just like my father had when I was a child.

The Women's Liberation Movement rescued me. In fall 1968, a college friend, Barbara, invited me to a meeting of Redstockings, which planned to protest a New York State legislative hearing on abortion reform (February 13, 1969). The only female expert witness was a nun. At the meeting, Anne Koedt distributed mimeographed copies of her influential essay, "The Myth of the Vaginal Orgasm." But Redstockings was not for me; there was too much

anger in the room. I reasoned that, with all my fury at my father and resentment of my brothers, such anger meant a clean break with men, and that I was loath to do.

Still, I was a feminist. I had lied to obtain birth control. My friend Barbara had become pregnant, and her parents had insisted that she marry her boyfriend, put the baby up for adoption, and get a Jewish annulment. My friend Jeannie had known worse. So I searched for an organization that suited me. I heard Robin Morgan at a meeting of WITCH (Women's International Terrorist Conspiracy from Hell), and Kate Millet at Columbia University. Finally I joined a consciousness-raising group affiliated with New York Radical Feminists, which accommodated a range of responses and viewpoints.

I decided to go to graduate school and study women—but what university would admit me? I had a Fine Arts B.A. and no Graduate Record Examination scores. I excelled in writing and reading comprehension but not on objective tests.

Luckily Rich had met, on a Montauk beach, the nanny of the children of Peter Berger, author of Invitation to Sociology, a widely read book based on philosophy, psychology, and history. Berger headed the social theory Ph.D. program at the New School for Social Research, which was open to anyone with a bachelor's degree. I gathered my courage and made an appointment. In his book-lined office, he encouraged me to apply and asked about my interests. "Woman's oppression," I told him.

He eyed me in my scooped-neck yellow-and-orange striped knit mini-dress, revealing my legs in sheer pantyhose and remarked, "You don't look oppressed."

Rich, Riverside Drive, New York, in July 1970

In fall 1969 I began the New School's M.A. social science program, and we found a small, affordable rent-controlled apartment near Columbia on Riverside Drive. I was terrified of failing, so I worked extra hard. From Emil Oestereicher, a young refugee from Hungary's 1956 uprising, I absorbed the ideas of Max Weber, Emile

Durkheim, Karl Marx, E.P. Thompson, and Eric Hobsbawm. My scattered perceptions of society fell into place, opening a new perspective on the world. I passed two six-hour, hand-written exams to get my M.A., and to qualify for the Ph.D. program, with flying colors.

I wanted to study women, but which women and where? My friends in New York Radical Feminists believed in sisterhood, that feminism benefited all women, except for the privileged few; I don't recall who was the first to say, "Jackie Kennedy is not my sister." But at a Thanksgiving dinner, Uncle Sam led me to question this concept of sisterhood. He pointed out that the National Organization for Women (NOW), a largely white, middle- class organization, sought to repeal labor legislation, which had been passed in the 1920s to protect women factory workers from heavy, dangerous work. NOW argued that women were not so fragile that they needed protection and had a right to do the same work as men. Sam's point was that the working women he represented wanted protection from harsh conditions. I had an aha! moment. Working women's interests were distinct from those of their more prosperous sisters.

At the First Congress to Unite Women, May 1969, I attended a workshop about how women are divided. As I sat in the front row, I heard a voice in the rear talk about race and class divisions among women. I turned: The speaker was Betty Friedan. The following May, at the Second Congress to Unite Women, I learned about other splits among women. At the plenary session, suddenly the lights went out. Moments later the hall was re-lit, revealing women standing in the room clad in lavender t-shirts labeled Lavender Menace, Friedan's term for Lesbians. Women I recognized from meetings

walked up front to the microphone and described hiding their sexual orientation from those they worked closely with. I was touched by what they endured and decided to study differences among women within the Woman's Liberation Movement.

My reading took me to the past, and to my surprise I loved research. I'd forgotten my dream of being a researcher when I wrote about radiation in high school. When I read Lucy Stone's essay in History of Woman Suffrage, I understood why my stomach tightened at the thought of being a dependent wife. Stone, part of the first generation of women to have the same education as men, was expected to stay home, embroidering "little cats on worsted and dogs on punctured paper." If she went "into the world" for a "worthy purpose," she was criticized for being "out of her sphere." A century later, I experienced the same frustration. Until the 1950s, the few college-educated Americans were white men. As universities expanded, white working- and lower middle-class daughters also went to college, but not, like my brothers, to study for a profession. I, equally well educated, was to have a skill "to fall back on," such as typing, should my husband die. From Betty Friedan, I had learned why I didn't want a conventional woman's life. Now I understood why I yearned for a meaningful occupation.

In 1965 I had taken Bill's name because that was what women did, but too many other women were named Carole Miller. In 1971 I returned to Turbin, the name that identifies me, who I am, where I came from, and is also unusual and easy to spell and pronounce. My mother continued to address letters to me as Mrs. Carole Miller.

I was lucky. Emil Oestereicher, my dissertation adviser, understood that my research on antagonisms between woman's rights ac-

tivists and working women's unions in the mid-1860s was part of the emerging field of social history, which challenged the traditional Great Man approach. And I met Alice Kessler-Harris, who was writing the definitive book on working women's history. We became dear friends, part of a network of women scholars who created the field of women's studies through research, writing, and teaching.

Bill's Ph.D. dissertation required research in London, so in June 1971 we sublet our apartment and flew overseas. Jet planes had replaced twelve-hour propeller flights, and ocean liners were on the way out. Before leaving for London I had acquired the address of the London Woman's Liberation Workshop and copies of Notes from the Second Year, feminist essays from 1968. One afternoon, I took a city bus to a brick row house in Islington. A young woman welcomed me and my pamphlets and invited me to a meeting. There I met Sheila Rowbotham, who was writing Women, Resistance, and Revolution, a history of U.S. and European feminism. She invited me to join her at the British Museum Pub and then to her home in Hackney. We ate steak-and-kidney pie and trifle (layers of whipped cream, jam, and yellow cake), compared women's liberation movements in New York, London, Amsterdam, and Paris, and became life-long friends.

Though Bill and I both longed for security, we hadn't settled down. In our sixteen years of marriage, we had lived in nine apartments, all furnished with "finds"—a faded Oriental rug we discovered in our building's trash room, and unfinished dressers bought in junk shops. The longest we lived in one place was on Riverside Drive. When Bill got his first teaching job at Princeton in 1973, two years before receiving his Ph.D., we decided not to move to New

Jersey. We loved our apartment, and I was still taking classes at the New School. But in 1975, when he began teaching at SUNY, Stony Brook, we moved near his job, to Port Jefferson, Long Island; I had a two-year position there and was writing my dissertation. When Bill got tenure in 1978, he wanted to continue living near Stony Brook. But my dream was Manhattan. So that year, when I got my Ph.D. and a job at Vassar College, we compromised on Brooklyn. First we rented an apartment; then we decided to buy a house. It made sense. Manhattan rents were rising, and we wanted to own a home. Having saved my salary for a down payment, we hoped to afford Park Slope, which was convenient by subway to Manhattan and by car or the LIRR to Long Island.

We were determined not to buy a house that needed renovation, but the three-story brick on 11th Street, built in 1879, was what we could afford. The real estate listing promised Victorian detail and five marble fireplaces. We found a former single room occupancy with rusted sinks, sagging ceilings, cracked linoleum, and the leavings and odors of generations of cockroaches. The agent showed us what she termed "an octopus" in the basement—a coal furnace converted to gas, with galvanized-steel arms reaching from an asbestos-covered structure to ceiling beams, just like the one in the house where I grew up. A few years later, friends confessed that, when they saw the condition of the house, they had been convinced we made a mistake.

I fell in love at first sight. A catalpa tree, higher and older than the house, shaded the backyard. From the upstairs front windows, I could see a dormered roof across the street. From the top of the stairs, I looked down at a graceful banister and light streaming

through floor-to-ceiling windows. We made the down payment, took out a sixteen-percent mortgage, and borrowed from friends to renovate.

Once again, anxiety over major life changes led to immobilizing lower back pain. So for three months Bill took on the task of hiring, supervising, and assisting workers who pulled down wood paneling, repaired walls and ceilings, removed linoleum, and created a new

374 11th Street, Brooklyn, New York, in the 1980s

kitchen of our dreams. I managed to pack our belongings, hire and supervise movers, and unpack. I wrote my first essay for an academic journal. After four job interviews, I accepted a tenure-track position at Empire State, a non-traditional SUNY college on Long Island.

At the time 11th Street was considered to be two blocks south of Park Slope. The house next door was abandoned, and nearby shops were shuttered. In the evening the subway station was deserted. I dared not walk alone in Prospect Park, even during the day. Sidewalks were littered with discarded syringes.

But by the 1990s Park Slope had come to us. Empty storefronts became restaurants, bookstores, and boutiques. New residents restored boarded-up houses. Crowds of young people emerged from the subway station, lugging musical instruments or backpacks full of books. Joggers circled the ring road in the park. The corner mom-and-pop grocery store gave way to a bistro with sidewalk tables shaded by umbrellas, like the ones I had seen in Paris.

I felt far away from art. I displayed Uncle Harold's artwork on the walls of our home, but not my own. I had forgotten about the painting of semi-tropical plants. I don't recall where I had stored it—perhaps in the garage, or the basement in Auburndale. My wise psychotherapist, a musician, helped me recover from my anxieties. She said I would not complete therapy until I brought art back into my life. It took me fifteen years to take her advice.

MAGIC SHOW

For children ages 6 to 12
TURBINO AND HIS MAGIC

Wednesday, August 15 at 11 a.m.
Cambria Heights Branch
220-20 Linden Blvd.

Friday, Aug. 24 at 2 p.m.
Rochdale Village Branch
169-09 137 Ave.

Thursday, Aug. 30 at 2 p.m.
Ozone Park Branch
92-24 Rockaway Blvd.

Admission is free. Tickets are required

QUEENS BOROUGH PUBLIC LIBRARY

Magic show flyer

8.

Illusions

WHEN I RETURNED TO NEW YORK in Fall 1966, twenty-four, married, and absorbed in my life, my father, at fifty-seven, had fulfilled his dream to sell for himself. In 1965 he had retired from Con Edison with a disability pension. He had a full-time souvenir business, and his merchandise had been featured at the 1964 World's Fair at Flushing Meadows.

In a story entitled "The End Justifies the Means," he describes his scheme for getting the pension. Phil Jackrow, a fictionalized version of himself, longs to quit his job as a telephone repairman and build up his publishing business. One day he wakes up with leg pains so stabbing that he can't go to work. His condition improves after chiropractic treatments, but when the company doctor visits his home, he pretends to be disabled. Bill and I actually witnessed this ruse, which occurred in June 1965, when we were staying in Auburndale before our wedding. While my father waited for the

Mecca for Merchandise

What's news from New York's Toy and Variety Merchandise fairs

By IRWIN KIRBY

Photos by AB

My father at an exposition of souvenirs
sold at the New York World's Fair in 1965

doctor to arrive, he asked Bill to watch for his car from the front porch and signal him to race upstairs to his invalid bed.

The doctor refers Phil to a neurologist, and with some misgivings (which my father had himself), Phil fakes a limp, sits stiffly on the edge of his chair, and claims that his leg is numb, because he knows this is a symptom of a more serious problem. The neurologist recommends surgery, but Phil refuses, claiming that people who had back surgery were often worse afterward. After a few months, company officials insist on meeting with their disabled employee. They send a limousine to his home and drive him to a luxurious executive suite in Manhattan.

Phil (like Bill Turbin) desires a disability pension as a safety net in case his business does not turn enough profit. He has slyly calculated that his employers will be more likely to give in if he plays the part of a breadwinner who wants to support his family but can't do so on a pension. When the executive insists that he take a pension,

he pretends to consent reluctantly on the condition that they allow him to return to work if his health improves. As he leaves the office, he fakes a dejected look but is inwardly jubilant (like Bill). "I've won! I've won!"

My father wrote this story for the Famous Writers' School, which he had learned about from the inside of a matchbook cover (a common site for advertising in those years, when most people smoked cigarettes). The school was as dishonest as he was. About ten years after its establishment in 1961 by publisher and writer Bennett Cerf, author and political activist Jessica Mitford exposed the school's shady academic and business operations. The "famous writers" who supposedly reviewed students' work were actually unknown free-lancers. My father typed his stories at the dining room table and mailed them to the school for review. When "The Means Justified the Ends" was returned to him, he gleefully showed me the comments: How do you expect your readers to believe such a stupid, dirty plot? The instructor didn't realize that truth is stranger than fiction.

At family dinners, my father still regaled guests with sexy jokes but no longer sputtered angrily at disagreements. In the past he had rarely given me a gift, but now on Christmas he presented me with a small white box featuring the black Chanel No. 5 logo, which he boasted he'd got at a discount from a customer. He hired Bill, as he had Uncle Al years ago, to load cartons of souvenirs into a blue Chevrolet and deliver merchandise to customers. He paid well. As students living on Bill's fellowship and my part-time work, we welcomed the money.

He indulged his love of gambling more than ever. When I was

growing up, he read the racing news and placed bets at Belmont Track in Queens. The names of horses—Seabiscuit, Citation, and Native Dancer—were household words. Until off-track betting was legalized in New York State in 1970, he bet with bookmakers. On journeys to Atlantic City to sell souvenirs, he played blackjack, disdaining the slots because they required no skill. In the 1970s, my mother accompanied him and browsed in luxury clothing boutiques while he gambled. He explained in an essay his strategy for coming out ahead: Always bet higher on a winning streak than on a losing one. Actually, his tactic was to quit while ahead, because he hated to lose. Once he sent me a postcard from Las Vegas with a poem:

> *Here I am in the land of chance*
> *where most men lose their pants.*
> *But as for me, I am far too shy—*
> *all I lost is my shirt and tie.*

Once, only once, he won big. His story "Winning the 'Pappaletta'" was about playing the Daily Double in Puerto Rico on a vacation with my mother during the Christmas holidays. At the Horse Parlor, an off-track betting spot, he could not bet on one race but had to pick winners for all six races the next day. He identified the handicappers' favorites in the racing sections of local newspapers, and "the clerk punched out seventy-five tickets, all with six holes corresponding to each entry." The next day, by a fluke involving a horse being disqualified and the importance of Christmas in Puerto Rico, two of his picks won their races. He picked up his

$2,739.00 in winnings—the equivalent of almost $17,000 today—stuffed the bills in his pockets, and tried "to appear nonchalant" as he hailed a taxi to his hotel.

In 1976, at sixty-seven, he decided he was tired of running a business yet wasn't ready to retire. So he sold Souvenir Sales to a customer, Manhattan Post Card Publishing Company, and negotiated a salaried job managing the firm's souvenir department. A noncompete clause stipulated that he could not sell souvenirs on his own for ten years. At that point he would be seventy-seven, presumably too old to work.

But he had forgotten that he hated being an employee, and in a few months was furious with his supervisors. Still, he persevered until the ten years expired, and then returned to selling souvenirs and was still doing it at eighty-five.

In the 1970s, for the first time that I can remember, my mother seemed content. She could afford to buy the luxuries she had wanted for years: air conditioners, a dishwasher, a blender, and Finnish Arabia ware. She replaced the kitchen and bathroom linoleum with ceramic tiles, and the ordinary dining room light fixture with a jewel-colored stained glass hanging lamp made in Mexico. At Saks Fifth Avenue and Altman's, she bought antique jewelry, a sheared beaver jacket, and Coach handbags. Instead of dying her hair black with Clairol at the kitchen sink, she became a strawberry blonde at a beauty parlor. She had her ears pierced, breaking with her parents' belief that only peasants wore baubles dangling from holes in their ears. She bought brand-name watches (actually knock-offs from street vendors). And she achieved life-long dreams: A baby grand piano stood on a shaggy gold wall-to-

Souvenirs and Novelties magazine cover,
just before my father sold his company

wall carpet in front of gold-toned drapes covering windows to the front porch. She learned French conversation from phonograph records, and, with Aunt Jean, she visited Paris, where her mother grew up.

She took me shopping at Bloomingdale's in Manhattan rather than at Gertz in Flushing. Like other feminists, I parted my long hair in the middle, wore gold wire-rimmed glasses, and often dressed in bell-bottomed pants topped with a tailored blouse and blazer. But I also had a taste for glitzy department stores and fashionable clothes like mini-skirts that showed off my legs. We lunched at the Russian Tea Room—no more Woolworth's lunch counters—where we once spotted Harry Belafonte wearing a black armband because he was grieving Martin Luther King's assassination. I had learned to be more direct with my mother, rather than passively accepting her complaints. When she criticized her parents for not encouraging her to finish high school at night, I retorted that it was time she stopped blaming them and got the education she wanted. When she objected to something Aunt Jean did, I replied that she should talk to Jean about it, not me. I told her I didn't want to hear about my father's problems with impotency. (It seems that, even after sleeping with Mrs. Magee, his troubles were not over.) My mother dropped the subject, and so did I.

It seemed to me that my parents' marriage was happier. On Saturday evenings, they would drive their new white Dodge Dart to Manhasset for a continental dinner and film. Going out together had always been the best part of their relationship. My father could be generous, willing to spend money on a cocktail and an expensive meal, and my mother loved displaying her beauty

My parents dining in the 1970s

and style. In winter months, when the souvenir business was slow, they jetted to Israel, Florida, Puerto Rico, or Las Vegas. Finally, my mother enrolled in college and studied music theory and art history.

But I was wrong. My father became more open about his affairs. When he introduced me to a large, brash woman who taught a course he was taking on the travel agency business, one of his schemes that did not work out, I knew they were lovers. At first my mother seemed to accept this. Then she told me that he had gone too far. On a visit to Israel with her, he had purchased a necklace for his latest woman at an outdoor market. My mother had said nothing about the lover, but insisted that he buy her jewelry, too.

She'd chosen a silver filigree Yemenite choker, which she later gave me. When they returned home she had accused him of having a girlfriend and thrown him out of the house. He had rented a room in an apartment in Manhattan.

I got my father's version of their breakup when I recorded his stories. In 1974, as they were about to fly to Hawaii to visit Rich, he told me, she'd broached the subject in her oblique way: "Things have changed over the years." After years of second-guessing her, he had understood that she was suggesting a separation. He'd agreed to part because, he said, the marriage was "pleasant but loveless" and he "enjoyed other women more." In Hawaii my mother had told him she had second thoughts about separating—and he had gone along. But when they returned from the trip to Israel, she'd changed her mind again and told him to leave. This time she had been in earnest, so they'd parted.

I was proud of my mother. After years of complaining about her disappointments, she was taking charge of her life, much like the older students in my Women's Studies classes. She still gave piano lessons—her pupils were children of Flushing's Chinese and Korean immigrants—but it was years since she had played Chopin's Études or the "Moonlight Sonata," so she took lessons herself to regain her fingering skills. She joined a health club where she took yoga classes and swam laps in a pool. She began group therapy to help her with anxieties about her new life. I cheered her and my students on, with no thought to how an older woman with no professional training would manage financially. Her piano-teaching income was not enough to live on.

Pretty, shapely, and seeming younger than her sixty years, my

mother looked for another mate in the same way as in her youth, at dances, often at Roseland in Manhattan. I was amused by how she managed the men she met. If one was attractive, she pretended to be younger than she was by lowering the ages of her children. If her pursuer was unappealing, she gave him the wrong telephone number. Within a few months, at a singles weekend in a Catskill resort, she met a wealthy widower whose wife had been her close friend. They had lost touch because the friend and her husband disliked my father's crude behavior. Her new suitor had refined manners, gave her expensive gifts, and proposed marriage. Yet she remained in touch with my father, and he supported her, paying her utility bills and college tuition.

To my disappointment, after about a year of separation, he began to go to Auburndale on Saturday nights to court his wife and take her to dinner and a movie. According to her, he missed his home; he had rented a room and was sharing the kitchen and bathroom, which the landlady complained he didn't keep clean. My father's story was different; he had a "nice studio apartment" in Manhattan and was having "the time of his life." He had arranged his life to keep his options open. He enjoyed his freedom and a lover while maintaining ties with his attractive wife and suburban home.

I knew my mother was anxious about her new life, because she was in group therapy and had complained to me and to my brother Ron of heart palpitations. She described her situation in her usual indirect way; she "had one man under the bed" and "another coming in the door." I assumed that, by seeing both her suitor and her husband, she had also kept her options open and avoided choosing between ending her marriage or returning to her old life. But now she

worried about ushering one out the door before the other arrived. I asked her what she planned to do. She said she had told Dad, "The door is open."

I don't know whether she invited my father to return because she feared upending her life by divorce and remarriage, or her suitor's gallantry and wealth had lost its charm. He stooped, walked with a cane, and had only a fringe of white hair. At sixty-seven my father had a full head of hair, graying only at the temples, was straight and slim, and had gained just enough weight to give him the robust look of a prosperous aging man.

In the end, he accepted her invitation to return.

I felt betrayed. I had admired my mother's courage, encouraged her struggles, listened to her troubles, and tried to soothe her loneliness. Now she quit group therapy, yoga, and swimming. She rarely practiced the piano and ended her lessons: "Too expensive." I understood this as an excuse for giving up on her independence. She accepted my father's affairs, which he kept under wraps, at least to her and me but not, I discovered a few decades later, to my brothers.

When I asked why he had returned, he replied that his girlfriend had left him when she discovered he was not divorced and was still paying his wife's bills. Also, he was planning to retire from the souvenir business and missed the big Auburndale house. At the same time, he knew that Mom was having "psychological problems." His sympathy for her was the tender side he rarely revealed.

Meanwhile, my father had discovered a new thrill: magic. He had always relished performing. At meals he would sometimes pretend to coax the last drops of catsup from a bottle by squeezing the glass. When pouring milk or juice from a pitcher, he would raise

the container above the cup, creating a long, thin stream that threatened to spill onto the table. The more my mother protested, the higher he raised the container. Once he entertained my brothers and me by ripping a threadbare cotton undershirt (soon to be discarded) from his body. This made me think of Clark Kent tearing off his suit in a telephone booth.

At family get-togethers, he could be high-spirited. When he told crude jokes and recited racy limericks to guests, his speech was fluent, his eyes sparkled, and his face flushed with excitement. At my cousin Matt's bar mitzvah party, I was fox trotting with a friend of his when my father danced by and lifted a glass to us with a gleam in his eye. My partner quipped, "You gotta watch out for the drunks around here."

I was amused and said lightly, "That's my father." The poor guy, mortified, fled and disappeared into the crowd. I was too shy to go after him to tell him I wasn't offended.

My father probably first became intrigued by magic tricks at Lou Tannen's Magic Shop, which he knew because they also sold his souvenirs. He learned basic techniques from the shop's salesmen, practiced at home in front of a mirror, and polished his skills at family parties. After a while, he became so expert that the salesmen would invite him to practice with accomplished magicians in a back room reserved for special customers. Then in the late 1970s, he noticed a course, "Magic for Beginners," in a catalog of Stuyvesant High School evening classes. He took the course, taught by Samuel "Zavello" Wishner, five times. After two semesters, in 1981, he became the assistant, helping teach students who had difficulty mastering tricks. Later, he performed at the first class of the term, serving as

the opening act before the instructor appeared. To publicize himself as a magician, as he had with his dances, he contacted the editors of Con Edison's employee newspaper, Around the System. "Retiree's Second Career...It's Magic!" appeared in 1982.

Bill Turbin was remarkably like Zavello, a Jewish immigrant born in 1920, who invented tricks that he skillfully promoted and marketed. Novelist and poet Paul Auster, who was his grandson, describes him as a poor Jewish boy who became an accomplished amateur magician, "a deft sleight-of-hand artist." Like my father, Zavello schemed, made deals, gambled, and "cheated on his wife." And my father, like Zavello and Houdini, who was also Jewish, took an Italianized stage name: the Great Turbino. He joined the Magician's Guild of America and the International Brotherhood-Sisterhood of Magicians, Harry Roz-on Ring 26, housed in a brownstone on East 36th Street near Lexington Avenue, and displayed his membership card in his wallet. After a lifetime of practical jokes, reciting racy poems, selling appliances that promised ease and glamor, promoting cheap romantic evenings, and selling cheap souvenirs bearing memories of iconic monuments, now he captured people's attention and deceived them in a more formal and theatrical way. With his intense looks and salesman's patter, he sold his own personality.

I much preferred my father's grabbing attention with magic tricks to crude jokes. The Great Turbino's special talent was performing in intimate settings, impressing his audience from a short distance, like a salesman displaying wares. At family occasions he would gather children around him, taking care that they not notice he was wearing a flesh-colored plastic thumb. Then he took a dollar

bill from his wallet and changed it into a twenty, which he had hidden, folded, in the false thumb. Explaining that he risked arrest because manufacturing money is illegal, he transformed the twenty back into a dollar. At other times he would cut a newspaper into tiny pieces and miraculously make it whole again. He did the same with ropes.

Like a salesman who keeps his audience's attention with a continual patter, he distracted onlookers from his maneuvers by dramatic gestures and constant talking. Often his astounded viewers would ask, "How did you do that?" Sometimes he delighted children by explaining his tricks and showing them his false thumb. Mostly he didn't reveal his methods, in keeping with the rules of professional magicians and his own penchant for secrecy. Instead he replied, his eyes sparkling, "Very well, thank you."

Another specialty was card and number tricks. He would take playing cards from his pocket, ask someone to silently choose a number, and then amaze them by naming the card they'd picked. Or he would ask an onlooker to pick a card silently and then produce that precise card. The number tricks were based on the fact that, if you perform certain mathematical operations on a number, the answer always comes out the same. This is also true of the following: No matter what number is chosen, after multiplying, adding, and subtracting as he directed, the letter, country, animal, color, and punch line will be the same. After he died, I found the directions for the trick, which he had typed on bits of paper and memorized.

Pick a number between two and ten.
Multiply that number by nine.

Add the two digits of the answer.
Subtract five from the result.
Locate the letter of the alphabet corresponding to the
number.
Think of a European country that begins with that letter.
Identify an animal that begins with the second letter
of that country.
Think of the color of that animal.
The punch line: "I didn't know that there were gray
elephants in Denmark."

He promoted himself as a volunteer magician for local senior centers, veterans' organizations, and public libraries, especially programs for children. On these occasions, he wore a black top hat and cape with red lining, and carried a black walking stick. With a flourish, he pulled from the top of the stick masses of colorful silk scarves. Often he boasted that he received at least one invitation a month from schools, libraries, and hospitals in Queens, Manhattan, and Ron's neighborhood in Nassau County. Just as with dance publicity many years before, he pasted in an album every invitation and letter of appreciation, some in schoolchildren's writing and others typed on official stationery.

The Around the System article reported that he had once "played the Garden." What actually happened was that, during an intermission of a performance by Richiardi (Aldo Izquierdo), famous for dramatic and gory presentations of classic stage illusions, he caught the attention of children seated a few rows away from him. The Great Turbino reached into his pockets for his

props and demonstrated a few tricks. Soon people seated nearby noticed his improvised performance and gathered around. He quite literally rose to the occasion by standing on an empty seat so the crowd could see his routines. By the end of the intermission, there were "perhaps a thousand people watching. It was the thrill of my life."

William Turbin amazed students with his magic tricks during a recent performance at P.S. 188 in Manhattan.

Photo by Tony Foschino

My father performing a magic show at PS 188, New York

I watched my mother tolerate his attention-grabbing ways. He would perform wherever he found himself—walking down a street, sitting in a bus, subway, or airplane, or, to my mother's dismay, in a movie theater or restaurant. He showed tricks to the waiter or waitress who took our order, the server who brought meals, the cashier who took his payment. As soon as we were seated, if he spotted children at a nearby table, he would get up and approach them. They were spellbound. The adults would praise him and smile appreciatively, despite the interruption to their meal. He was so absorbed in his performance and delighted by the rapt attention of his

audience that he ignored everyone at his own table. My mother, as always, was silent. She sat stiffly, looking at her plate of food, at her lap, or into the distance.

Sunday 6:30 A.M. — July 16, 1949
after 2 hours of sleep

Dear Diary

No matter what may happen
its better than this. Last night
Richie woke me. I really could
have strangled him. As it is
I punched him hard enough
to make my knuckle tingle.
He shut up in terror. Richie
is 4½ years old. Am I the type
to punch babies just because
of a broken sleep? If I am,
have I always been?

I believe it is a question
of a distorted and supressed
home life. After I hit Richie,
I could not sleep because of
the many disturbances
running through my mind.
First, it was the discouraging
thought that I could not talk
over problems with my wife

My father's last diary entry

9.

Openings

I N 1974, WHEN I WAS THIRTY-TWO and my father was sixty-five, he handed me his diaries from 1927 to the 1940s. He said, offhandedly, that he knew Bill and I were "interested in history." Later, leafing through the three lined notebooks, I happened upon his last entry, dated July 16, 1949, written at 6:30 AM on Sunday morning, "after two hours of sleep":

> No matter what happens its [sic] better than this. Last night Richie woke me. I could have strangled him. As it is I punched him hard enough to make my knuckles tingle. He shut up in terror. Richie is 4½ years old. Am I the type to punch babies because of a broken sleep? If I am have I always been?

He realized that his problem was "a distorted and suppressed home life." He could not talk "over problems" or "have a heart to

heart" with his wife, his "life's companion." She claimed that "spats" were routine in marriage and should "be forgotten," as if "they never existed." After "ten years," he gave up and decided to make the most of "a disagreeable situation." After all, "children should not be reared in an atmosphere of marital discord." He "gritted his teeth" and avoided talking "over anything but pleasantries." When controversial situations arose, he "did not argue but resolved them" in his way. If she did disagree, he stuck to his "guns."

Still, he continued, he had to "seek mental exhilaration in my harmless way." His wife never referred to "specific instances," but she showed disapproval when "I enjoyed myself without her companionship." She, who "should" try to "appease me," begrudged him "brief moments of joy." At times, the relationship was "sickening." He kept going because he realized that she "meant well" and tried to do her best and "comfort and please me."

At the final paragraph, my heart melted. He wrote, "I would like to live this thing out for my little girl Carol[e]," the "sweetest and most intelligent thing imaginable. My heart is sobbing while I write this. What am I going to do? What am I going to do?" At the last line I took a deep breath. Emotions flooded me. My father adored me. He knew what I had long understood about my mother. She refused to discuss feelings. Her eyes rarely met mine. She could not give support. And it was clear that my brothers, too, had felt the sting of my father's anger and a slap from nowhere. I could read no further. I packed the diaries in a box and stored them in our basement, where they remained buried, along with my fond feelings for my father, for over thirty years.

Looking back now, I realize that the bond with my father had

lain under the surface of my awareness all along. After he died, I found in an album a snapshot taken in 1960, the evening after my high school graduation; I was eighteen, and he fifty-one. He smiles as he sits beside me on the piano bench, turning toward me, and I

Celebrating my high school graduation in 1960

lean toward him almost flirtatiously. I was touched. I remembered the snapshot taken so long ago in Inwood of him holding me in his arms, and noticed that the edges of this one were cropped to fit a wallet and tattered from frequent handling. He must have removed it often to show it off. Beside the frayed photo, protected in the album for almost fifty years, was one of my mother and me on the same evening. We stand in front of the piano, our arms stiffly around each other, smiling at the camera but not at each other.

In 1976, after my parents had been separated for about a year, I began to feel more sympathy toward him. I must have missed him, having not seen him all that time. My anger had subsided; I viewed my mother as complicit by tolerating his affairs for so long. So I invited him to dinner, and he accepted, though Bill and I were living in Port Jefferson, two hours from Penn Station via the LIRR. But he wanted to bring his lover. This was too much; I refused. In 1970s hip parlance, he pleaded, "Why can't you be more hang loose about this?" I stood my ground, and he came anyway. I was pleased, so I served a meal I knew he would enjoy and listened to his stories about himself all evening.

My heart opened to my father even more in September 1982, at my cousin Barbara's lavish wedding at the Shaker Heights Country Club. My mother took the place of her sister, Lil, who had died of lymphoma the previous year. At sixty-eight, in her prime, she had been a city councilwoman in Shaker Heights. My mother had appeared impassive at the funeral and said she envied people who could cry. At the wedding, I was matron of honor, carrying a bouquet. As I posed for a photograph, my father, seventy-three, grasped

My father and me at Cousin Barbara's wedding in Fall 1982

my arm and stood beside me. To my surprise, I welcomed his touch.

Six months later, on his birthday, May 31, I stood in line in Manhattan's grand General Post Office on 8th Avenue, holding a manila envelope containing a proposal for a National Endowment for the Humanities Fellowship for College Teachers, due in Washington, DC, the following day. The circus was in town. Clowns with white faces, red noses, and yellow hair were also waiting to mail packages. Tears came to my eyes as I recalled my little-girl self seated beside my father, watching the world-famous clown Emmett Kelley chasing a spotlight with a broom.

After Lil died, my mother was more needy than ever and phoned me more often. My sympathy for her had vanished when she returned to my father, and my heart had opened to him. Still, I knew she had lost her only close friend, so I listened. Once she told me about clandestine meetings with Sam, her widowed brother-in-law. Having lost his beloved wife, he wanted to marry my mother, whom he knew was unhappily married. I wasn't surprised. I knew my mother didn't love my father, and that Sam saw her as more like Lil than anyone else he might meet. But I felt it was more than I should know about my mother, so I didn't respond, and she never divulged more. I revealed little about myself, since she rarely remembered what I said from one conversation to the next. What was more, if I mentioned a minor discomfort like a cold, she responded as though something truly terrible had happened and she needed my comfort. And I didn't trust her to keep confidences. I figured that, if she criticized my brothers or Aunt Jean to me, she would also complain about me to them.

In a snapshot taken on a Hawaii vacation in 1988, looking

younger than her seventy-three years, she posed in front of a water-fall with her arms on a railing behind her, as in the photograph of her at nineteen. Her hair was now reddish-blonde, and she wore a fashionably slim polo shirt and wrap-around skirt.

Three years later, in February 1991, she complained of unsteadi-ness, and we learned she had non-small cell, non-smoking lung can-

My mother on a visit to Hawaii in 1988

cer, which had spread to her brain. In a rare candid moment she said she wasn't ready to die. She wanted to see her grandchildren grow up and the book I was working on published. I was touched. She had never before mentioned my work.

My brother Ron and his wife, Judy, invited her to stay at their Nassau County home while she had radiation treatments in a nearby hospital. One Sunday evening after dinner, Ron, Judy, Bill, and I sat at the dining table while my mother rested upstairs. My father, for once not seeking attention, was seated in an armchair in the living room, leaning forward, his arms on his knees. His eyes, looking both inward and at an unfathomable distance, told me that he knew my mother was dying, though no one had said this. My heart reached out to him.

Now my mother really needed me, but I believed that I had to take care of my life. I had the professional recognition that I had worked for: a book contract with an academic press, and a position as visiting professor at SUNY Binghamton, where for the first time I taught eager, well-prepared graduate students. After teaching and preparing for classes all week, on Sundays I visited my mother in Nassau County. Meanwhile, I applied for jobs in colleges where I could teach advanced students.

I didn't tell my mother that I had a job interview at Occidental College in Eagle Rock, near Pasadena. The interview went so well that I expected to get an offer but then was dismayed when I did. Bill agreed to take a year's leave from his job at SUNY Stony Brook, so that we both could consider living in Southern California permanently. But moving cross-country, and assuming a new job, were the least of the upheaval in my life. Not only was my mother fatally ill,

but the following month I learned that I had an ovarian tumor. The gynecologist could not rule out cancer. In May I had a hysterectomy; the tumor was benign. I did not tell my mother, who was now hospitalized. Soon she would be gone.

Just before my mother became ill, Ron and Judy had proposed that my parents move to their neighborhood in Nassau County. My mother was eager. While she was being treated for cancer there, my father, eighty-two, sold the house and purchased a pretty garden apartment. He hired movers and packed his belongings. On a cool spring day, when the grand maple trees were still bare, I bade farewell to the Auburndale house. To prepare for the new owners, I swept floors and scrubbed the oven and kitchen floor. In my parents' bedroom I imagined my mother seated before the mirror of her art deco vanity, arranging her abundant hair. I lingered in the yard, where I had played hide and go seek. It never occurred to me to visit the basement.

Sadly, my mother never lived in the new home. The evening before she died, May 31, 1991, I held her hand as she lay in a hospital bed. I was forty-nine and she was seventy-six, her beauty ravaged by radiation and chemotherapy. A scarf masked the loss of her precious hair. I mentioned the new apartment, and she responded that she had never liked the Auburndale house. I asked why they hadn't moved. "Inertia, I guess." When she died the next morning, I was relieved that her suffering had ended. Then I noticed my reflection in my full-length bedroom mirror and felt another release. Never again would I hear her needy voice, feel her disapproval when she looked at me, or hear her critical tones when I saw myself in a mirror. Finally that voice was silent. Though many years have passed,

at moments when I'm dressing for a special occasion, I still feel relief at this silence.

The day after the funeral I browsed in Lord and Taylor's glittering jewelry aisle and recalled our shopping excursions, black-and-white sodas at Woolworth's lunch counter, and her gifts: Coach bags,

My mother's favorite jewelry.
Photograph by the author.

a Dansk soufflé dish, crystal candle holders, and pearls. When I wear the silver filigree necklace my father bought in Israel and the garnet ring she purchased with piano-teaching money, I think of how she gathered courage when my father went too far and continued teaching piano until shortly before she died.

A few months later, I learned more. Aunt Jean told me about my mother's mood swings after her hysterectomy. When I was thirteen, about to enter high school, she must have struggled with depression and anxiety while managing a household, three adolescent children, and a volatile, womanizing husband.

In August 1991, when I was still recovering from my own hysterectomy, Bill and I packed our Brooklyn household and moved to Eagle Rock. We rented a mountain-style house across from Occi-

The house in Los Angeles, across the street from Occidental College in 1991

dental College with a wrap-around deck, fireplace, and swimming pool. Bill did research at the Huntington Library in nearby San Marino, taught a course at UCLA, and returned home in the afternoon to swim in the pool before dinner. I walked to work through olive groves. I loved my students.

Yet I had lost my footing. I no longer had a mother, a uterus, or ovaries. I did not bleed monthly. Summer lingered into autumn, and winter never arrived. The sun set in the wrong place, over the ocean. Our house had no basement. The Soviet Union, and the entire political world I had grown up in, was gone. This time my anxiety took the form of insomnia, which I alleviated by cross-country phone calls to my psychotherapist and long walks among live oaks in the hills behind the college. I concluded that I was a dyed-in-the-wool New Yorker. I hated driving. I had turned fifty. A dream job was not good enough for me to give up my city ways and old friends. My new colleagues wished me well back East. In August 1992, we packed up our belongings once again and returned to our Brooklyn row house.

After my mother died, my brother Ron predicted that my father would continue with his current girlfriend. But no, he fell for one woman after another. I was amused. My mother was gone, he was eighty-four, and he and his spirited lady friends were having a good time. Petunia was a West Indian. Veronica lived in a luxury Battery Park apartment. Portia collected valuable oil paintings. Charlotte was a Holocaust survivor. Eda lived in Howard Beach, Queens. Silvia had a home in Florida. Only Marian, a nurse and former nun, who lived in the Berkshire Mountains, was a good deal younger than he. He charmed them with love poems.

Rain or snow, sleet or storm,
Your love will forever keep me warm.
Charlotte my darling, oh Charlotte my friend,
I'll be with you till the very end.

In 1993, at eighty-four, he decided that his Nassau County apartment was too big and the neighborhood dull. He put his name on a waiting list for low-income senior housing near Main Street, Flushing, run by a Jewish organization. To inspect his prospective new home, Ron and I took the LIRR from Penn Station to Main Street. The scratchy rattan seats had long ago been replaced by plastic. The small town of our childhood memories, where we had banana splits at Jahn's Ice Cream Parlor, had given way to congested streets with multi-storied buildings and signs in Chinese characters. The senior residence, a high-rise constructed in the 1960s, was on a side street, near the subway, the LIRR, and shopping. It was unadorned, clean, and light, with a spacious lobby opening into a garden. But the friendly social worker informed us that, alas, there was a long waiting list.

To our surprise, my father was informed the following week that a studio apartment was available. He was, after all, an ideal resident—a healthy, sociable male, a rarity among the elderly—and could afford the highest rent on a scale pro-rated according to ability to pay. The social worker counseled him, confidentially, that there was one problem: His total assets were too high for him to qualify as a resident. To get around this, she advised him to finagle, that is, to submit his application before transferring money from the sale of his apartment to his bank account.

Into a one-room apartment, he crammed my mother's cherished art deco bedroom dressers and Danish Modern sofa. My father, always oblivious to his surroundings, failed to notice that his housecleaner didn't vacuum dust, wipe kitchen spills and crumbs, or clean the bathroom floor and toilet. He often maintained that hair should be cleaned "with a fine-toothed comb" rather than washed in soap and water. He rejected new technology, refusing to use a telephone answering machine, microwave, or computer. And he would not replace aging appliances. When his toaster's on-off switch broke, he turned the knob with pliers.

He had no shortage of entertainments. Occasionally he took the subway to Lou Tannen's Magic Shop or the International Brotherhood-Sisterhood of Magicians on East 36th Street. Often on Sunday mornings he took a taxi to a Baha'i service on East 11th Street in Manhattan. Sometimes he boarded the "Chinese" bus to Atlantic City to play blackjack. Sitting in a rocking chair in his apartment, leaning against a plywood board to protect his weak back, he would down a daily shot of whiskey as he bet on horses.

He lived modestly but had more money than he had ever dreamed of and was more generous than I thought possible. He had sold the Auburndale house at 1990s prices and paid no capital gains tax because it had been a gift. Having invested in mutual funds in the 1960s, he had reaped the benefits of the stock market boom. He paid for my brother Ron's professional camera and my Toshiba laptop. For my birthday he often treated Bill and me, and Ron and Judy, to dinner and dancing at the Rainbow Room, atop Rockefeller Center. We swayed to the swing music of his youth on a revolving floor beneath a crystal chandelier, encircled by magical views of the

city. When he gave me a check as a gift, unlike my mother, he made it out to Carole Turbin. I smiled to myself.

Like a salesman displaying wares, he often showed the world his children's achievements—proof of his own success. In an album, he exhibited diplomas and honor certificates. To the entire extended family, he mailed a photo of Ron, a New York State attorney, shaking hands with District Attorney Robert Morgenthau, and copies of a $1.5 million check that Rich's Honolulu law practice had earned. He distributed articles about First Lady Hillary Clinton's "listening tour" in Upstate New York, in July 1999, and her speech paraphrasing my book on nineteenth-century working women in the city of Troy.

I observed that, with women as with gambling, he would quit while he was ahead or before he lost too much. He never broke off a relationship, just as he did not leave my mother despite the despair he wrote of in 1949. The exception was Veronica, whom he planned to marry only a month or two after my mother died. My brothers worried that he had agreed to marry her so soon, not because he believed they would be happy together, but because she'd refused to sleep with him until they were wed. Then, a few weeks before the ceremony, he canceled the wedding because she read the National Enquirer, a sensational tabloid. He liked classy women, like my mother. More typically, after a few months of hot romance, he would criticize a former darling and send love poems to another whom he met at a senior center dance. Most of his sweethearts were wise and spunky enough to realize when the party was over and retreat before they were badly hurt. For my father, in romance, gambling, and magic tricks, the thrill, however fleeting, was all:

Last night I held a little hand,
so dainty and so sweet,
I thought my heart would surely break,
So wildly did it beat.

No other hand in all the world
can greater solace bring
Than that sweet hand I held last night,
Four aces and a king.

As I watched each lady friend fade from his life I understood. He was in love with falling in love and infatuation, but incapable of deep, enduring love. His adored women were creations of his imagination. Love waned as the object of passion emerged as an ordinary human being with feet of clay.

During each love affair, he flirted with other women he encountered in his building, the hospital cafeteria where he took meals, wherever he found himself. He told me he had whispered to a woman seated next to him at a Bingo game, "Our eyes have met, our lips not yet, but O my pet, I'll kiss you yet." Others were likely more serious. Perhaps the widow who lived on the floor above him, a former delicatessen owner, supplied him with more than pastrami and knishes.

Only Roz tolerated his womanizing. Small, wiry and eighty-five, a few years younger than my father, she got what she needed and gave him what he wanted. He said she was "the least attractive woman I've known," but the "best in bed." Each week she took a bus from her daughter's suburban New Jersey home to dance at

Roseland in Manhattan. Afterward she spent the night with my father in Flushing. He gave her a key to the building's rear door, so neighbors would not see her. One Sunday afternoon, when Bill and I took them to a nearby diner for bagels and lox, my father strode ahead of her, exited the building before us, and waited outside. Roz, walking beside me in the lobby, said she understood: He wanted "to keep his options open."

My father gleefully told my brothers and me about the one time Roz had confronted him. As they sat beside each other on an eleven-hour flight to Hawaii to visit Rich, his wife, Rai, and their children, Roz had asked if he had gone to the Senior Center's Leap Year's Day dance, where women asked men to dance. He replied, "Of course not." She'd asked whether he was certain. He had insisted that he only danced with her. Then Roz had pulled from her purse a pho-

My father (far right, partly cut off) at a Leap Year Dance.
New York Times, Metro Section, February 29, 1996

tograph from the front page of the February 29, 1996, New York Times Metro Section showing him dancing with a woman. I imagine that her eyes had sparkled as she surprised him with the picture, though she accepted that this was another option he kept open. For his part, he had seemed as pleased with her cleverness at finding the evidence as with his having gotten away with going behind her back.

After he died, when I read the frank sexuality in his diaries, I wondered why he gave them to me, his daughter. Did he want me to see his better qualities, the ability to reflect, to feel remorse, and his efforts to do the best for himself and his family? Certainly this is the message in his first request for those words on his tombstone I first quoted earlier: He lied, he stole, he cheated, but he meant well.

Why, on that day at the beach when I was eleven or twelve, did he ignore me and play with another little girl? As an egocentric child, I concluded that he had transferred his affections to my handsome twin brothers. When I reflected on this as an adult, I recalled that he often said, if I wanted something from him, I should look at him with "my big brown eyes." Later, he would look at me wistfully and say that his "little girl is growing up." Was this his way of saying that my sexuality was emerging? Lacking impulse control, feeling intimacy only through sexuality, perhaps he managed his feelings toward me by detaching himself. For him, lasting physical and emotional intimacy was impossible.

Yet as he aged, I sensed his affection for both my brothers and me. "A Date with Destiny," which he wrote in the 1960s, using our real names, confirms this. In the story, a man regrets that he has never communicated meaningfully with his children and has failed to act on his belief in racial equality. To make up for this, he boards

a bus to a Civil Rights demonstration in Washington, DC. His dark business suit and polished shoes stand out among the boisterous, long-haired young people, and he imagines running into his children, whom he admits that he misses. Richie is studying law at Harvard, Ron is a graduate student at the University of Michigan in Ann Arbor, and Carole, recently married, is doing graduate work in Berkeley, California. Soon he spies Richie in the crowd and learns that soon Ron will arrive by bus. As he walks hand in hand with his two boys, one of them sees Carole and her husband, Bill, in the distance and calls out to them. The five family members march together hand in hand, singing, "We shall overcome." My mother does not appear in the story.

Carole Turbin, *My Father at 93*, 2002. Graphite powder on paper.

10.

"... Draw it."

FOR YEARS IT SEEMED THAT MY MOTHER had been right in claiming that my father was "made of iron and will live forever." He had an occasional bad cold, which he denied afterward, and some routine surgery. He claimed that his hernia repair was for cosmetic reasons; the abdominal bulge marred his attractiveness in nudist camps. In his seventies, he delayed surgery for an enlarged prostate until he could no longer urinate; late one night my mother called an ambulance. Recovering in the hospital, he entertained nurses, patients, and visitors with magic tricks as he strolled the hallway, pushing a pole with an IV drip. When cataract surgery restored his vision, his health seemed to improve. His siblings were similar. One by one their spouses died—Martha, Brita, Al, my mother, Sam, Ruby, and Selma—but all the Turbins lived on as robust as ever.

It wasn't until February 1995, when he was eighty-four, that I

noticed, sadly, that he had aged. His hair was grayer, he had lost a few inches of height, he was thinner, and he moved stiffly. At a party following a young cousin's bar mitzvah, he dozed in an armchair rather than delighting guests with magic tricks. Fortunately, soon afterward he had a medical checkup. His fatigue was not due to age but to serious anemia. He was bleeding internally because of malignant polyps in his colon.

I was fifty-two, my anger gone, and I wanted to take care of him. By then, I could see how much I was like him. Our handwriting is almost indistinguishable. I am tall, lightly built, slim, and deficient in *sitzfleish*, with black hair graying only at the temples. I am often more fluent in writing than speech, feel hopeless when I'm hungry, and am irritable when awakened from a nap. I hate being an employee and taking orders. I have attacks of lower back pain, which I alleviate by lying flat on the floor for five or ten minutes, as he often did.

The day he was discharged from the hospital, he insisted on walking to a hospital cafeteria near his apartment, where he flirted with the women who served meals. I worried that he was too weak to walk a few blocks and advised him to order food from his residence's dining room. He refused, so I paid for meals to be delivered to him. He had phoned me only twice in his life: in 1991 when he sold the Auburndale house, and in 1995 to tell me he was about to be hospitalized for colon surgery. Now he picked up the phone for the third time to say that he had had a delicious lunch.

A few weeks later, I drove him to see a medical oncologist in a Suffolk County health care center, the first time he had been a passenger while I was at the wheel. When he grumbled that I drove too

cautiously, I countered that, in the past year, I had gotten two tickets for running red lights. He was silent, which I knew men respect for risk-taking when I tried to get through the light.

It happened that the medical center was across the highway from the Jewish cemetery where my mother was buried. After seeing the doctor, we visited the grave, a foot stone near a moss-covered concrete wall. I said to myself, imagining her at seventy-five before she became ill, I know I was not the daughter you wanted. Yet you loved me and did your best.

The oncologist had recommended chemotherapy because of malignant cells in my father's lymph glands. My father considered this advice as we drove back to his apartment. He didn't want to lose his hair, his "crowning glory," he didn't want to suffer as Mom had, and he wanted to enjoy his remaining years. I advised him to follow his heart. Like a true gambler, he took the high-stakes risk and declined treatment. He won his bet and lived in good health for another eleven years.

I was proud of him. On a warm evening in June 2001, I sat on a folding chair at the headquarters of the International Brotherhood-Sisterhood of Magicians. Professional magicians performed in black tuxedos and silk top hats, accompanied by practiced assistants and soothing background music. Then Bill Turbin, ninety-one, clad in a creased Hawaiian shirt and baggy chino pants, unsteadily climbed the steps to a stage. The association's president, a curvy blonde woman, introduced him as the "the oldest active professional magician in the U.S." He tore newspapers into tiny pieces and restored them, cut ropes into segments and made them whole again, and pulled colorful scarves from his hat. He made a few errors but cor-

The Great Turbino performing a rope trick at the New York headquarters of the International Brotherhood-Sisterhood of Magicians on June 29, 2001

rected them with aplomb. Amid applause, he was presented with an award for years of voluntary public service.

The summer after that day at my mother's grave, I noticed that my visual awareness had sharpened. My eyes followed the lacy forms of tree branches and the dark edges of buildings and urban structures against a light gray or blue sky. I was attracted to sunlit patterns on the surfaces of objects and the deep hues of dark forms in the shadows beneath them. I peered through open doors framing interior furnishings. I began yearning to describe these shapes on paper. And I remembered my painting of semi-tropical plants. I carried it up from the basement, and hung it in the hall, by the stairway between the parlor and top floors of our house, and gave it a title: California.

I began to draw again and instantly felt the pleasure of focusing intensely on what I was depicting and of the tactile sensation of making marks on paper. But over the years I had lost skill and confidence, so I needed instruction. I had fond memories of scruffy art studios and the quiet companionship of others working at easels, each silently concentrating on a drawing. I had always liked the housekeeping aspect of artwork, sharpening pencils, preparing paper and canvas, and even cleaning brushes. So I enrolled at the Art Students' League, where I had supplemented college art classes in the mid-1960s.

On a Saturday morning in September 1995, my chest tight with anxiety, I entered the Beaux-Arts building on Fifty-seventh Street, bound for a life-drawing class. When I walked in the door, tears of relief filled my eyes. The League was just as I recalled it from the mid-1960s. Dented gray metal lockers lined the halls. The wooden

s were stained with paint. In the lobby, two phone booths stood de a stand holding a thick directory.

Six years later, when I was almost sixty, having renewed my skills in weekend and evening classes, I decided to retire from teaching and study art. If not now, when? On a September morning, the second week of my first full-time painting class, the subway was delayed. In the elevator of the Art Students' League, an older man remarked that a plane had crashed into the World Trade Center, like one that had hit the Empire State Building in July 1945. I remembered my father telling me that he had heard that crash. In class, a student announced that she had learned from a cell phone call (rare in those days) that the crash was not an accident but a terrorist attack. As sirens blared, we listened to radio reports of the collapse of the two towers. I called Bill, in Stony Brook, to say that I was safe and would stay overnight with friends on the Upper West Side.

From my refuge, I phoned my father. He told me that, early that morning before the crash, he had seen the Twin Towers from the window of his nineteenth-floor apartment in Flushing. Later, they were gone. Not a word about my welfare. I was not in the habit of revealing emotions to him, but on 9/11 even strangers shared feelings. I said I was in shock. He railed, "You're in shock? You don't know what it's like to be old. I can't chew, I can't see, I can't hear. Every morning I wake up at six and eat prunes and drink hot water with lemon."

What had I expected? He was an egocentric narcissist, unchanged from the diary-writing young man who recorded his emotional highs and lows. His agonies were of greater importance than a tragedy that I and many others mourned. I listened to him pa-

tiently, no longer angry. That was who he was.

In 2004 I learned a technique called wax resist that combined artistic elements I loved: precise drawing, intense darks and lights, expressive brushwork, and the problem-solving involved in designing a composition to convey specific emotions I wanted the image to express. In class we worked from models, but one afternoon at home I observed, as if seeing it for the first time, the bathroom sink. Like the one in the Auburndale house, it had been installed in the 1930s. Beneath its white porcelain bowl were angled pipes with gritty surfaces, sparkling highlights, and deep shadows. After creating a sketch and then a more complete picture, I recalled my father's words and the drawing I had done when I was five, almost fifty years before: If you're afraid, draw it.

As a child I had drawn the plumbing I feared and later had painted scary tropical foliage. Now as an adult artist, I created images of old sinks with chipped white porcelain bowls and angled plumbing and furnaces with metal pipes, ducts, and valves. I drew rows of bronze-plated Statues of Liberty with green felt bottoms in the basement of the Auburndale house. These objects had a history, a story, and carried memories, not only my own but also those of others who had lived with these things long ago. After a few years I discovered lithography, which is based on drawing, my first love, and requires a different kind of advance problem-solving—about, not only how to express emotions, but also what steps or techniques will result in which visual effect.

As long-buried memories surfaced, in my heart I relived the past. My bond with my father. His anger. My anger. My escape. Stories I had heard from my father, mother, aunts, uncles, and grandparents.

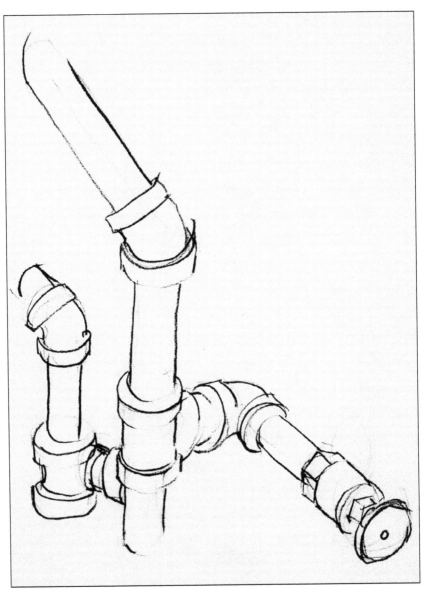

Carole Turbin, *Pipes, 1994.* Pencil on paper.

Carole Turbin, *The Lower Depths,* 2007.
Wax, black ink, charcoal, and conte crayon on paper.

A narrative formed in my mind, telling a more continuous story than the images I drew and printed. I knew I had to write this story, interspersed with pictures, to plumb and objectify my deepest, unuttered feelings. Writing was another, even more complete way of coming to terms with and accepting my father, my mother, and myself.

Putting words on paper was another link with my father. Although he quit the Famous Writer's School after the instructor criticized his disability pension story, he continued to write short essays in a salesman's hawking tone, trying to convince the reader of his point of view about winning at blackjack, Scrabble, and horse racing, the benefit of nutritional supplements, and how to cure chronic backaches and insomnia. His method of overcoming wakefulness at night was not reading or watching television until feeling drowsy, but reciting to himself songs he had memorized. After an hour or so of the lyrics of "Always," "April Showers," and Al Jolson's "Swanee," sleep returned.

He wasn't shy about presenting his thoughts to the world. In his early eighties he collected his racy jokes and poems into a pamphlet entitled Ice Breakers, or Making the Most of Your Dates: 115 Rib-tickling, laugh provoking adult poems, gags, and stories guaranteed to make you the life of the party. At ninety, he submitted his poem "Dr. King" to other local newspapers, which reprinted it. A year later, he paid a vanity music company, Hilltop Records in Hollywood, California, to set the poem to music and record it. They marketed it with other songs on a tape cassette entitled America. He was jubilant. He also paid the company to record Drusilla Megee's song, "Oklahoma Memories," taking credit for authoring

the lyrics and a simplified version of the music.

Was this his usual salesmanship and self-promotion, or had his judgment declined? Perhaps. Ron and Judy invited him to move to a private senior residence a few miles from the center of Lenox, Massachusetts, near where they had relocated from Nassau County. On a visit to the residence, my father was captivated by what he perceived as luxurious amenities and the excitement of change. I asked if he was sure he wanted to move, and whether the residence was in the country, suburbs, or town. He had not noticed.

I worried that he had no idea what he was getting into. Bill and I visited the residence. It was clean, spacious, and well run, but too hushed for my sociable, excitement-loving, self-sufficient father. The grounds were deserted. The building was set back from a fast-moving four-lane highway with no sidewalks, traffic signals, or crosswalks. It was unsafe for even an agile ninety-year-old like my father to cross the road or stroll along the shoulders to the nearest shopping center, which was almost a mile away. I warned him that he might feel bored, isolated, and, worse, lose his independence. But he was adamant, especially when he learned that Marian, his former woman friend who had been a nun, lived nearby.

It never occurred to him that he would be far from most of his family—which didn't surprise me. He had always disparaged his in-laws and siblings, except for Bertha. His mother had been neglectful, his father ignorant, and his brother George, whom he accused of losing the East 4th Street house, incompetent. His brother Charlie was stupid, and his cousin Julius, with whom he had picked up girls, had cheated him in the souvenir business. His siblings Irving, Mollie, Bertha, and Marian were dupes of Stalin. He had out-

lived all but Marian and expressed no sadness at losing those who had shared his youth. I noticed that he didn't think about being far from Bill and me either, and that he said nothing about missing Roz, though he mentioned that she was unhappy about his move. He was so narcissistic that the excitement of moving to a new place, like the thrill of infatuation and seduction, was all in all to him.

On a sweltering August day in 2002, Bill and I, and Ron and Judy, helped my father prepare to move. Whirring electric fans created a breeze. At ninety-three, clad only in shorts, he packed his belongings as he had his souvenirs. As I watched, I recalled him in the basement when I was a child, wrapping each object in newspaper and tucking it into a cardboard carton that was small and light enough for him to lift himself. He secured the box with gummed tape and twine that he had carefully saved. A few days later, we drove a rented van to Lenox and helped haul furniture into his apartment. At first Marian visited occasionally and drove him to shops and restaurants. A few times, Roz took a bus to Lenox. He performed magic, flirted, and bragged about his children. Ron helped him manage his savings and health care insurance.

When he lived in Flushing, we had felt he was doing us a favor by allowing us to treat him to a lunch of bagels, lox, and cream cheese. Now he eagerly asked me when we planned to visit. I said it would be in a few weeks and gave a date. That was not a few weeks, but a month, he reminded me: "You can't fool me." I was relieved; his mind was still sharp.

Yet age had caught up with him. He depended on us, and Ron and Judy, for gifts of Chivas Regal, and to shop for lemons for his morning glass of hot lemon and water. Socializing was difficult be-

cause his vision and hearing had deteriorated. Watching movies and television was impossible. After about two years, Marian and Roz no longer visited, and other women did not replace them. He often recited:

> *I am so sad and lonely,*
> *my flame of life is dying out.*
> *What used to be my sex appeal*
> *is now a water spout.*

His life's last joys were performing magic tricks and Scrabble. When I was twelve or thirteen, I played with him occasionally and once won because I could recognize subtle markings on the backs of the coveted blank tiles. I confessed that I had cheated. To my dismay, in the same tone he used to tell crude stories, he revealed my deception to guests who came to dinner. Afterward, I gathered my courage and declared that I was hurt. He replied that I was "too sensitive." I turned away silently and never played with him again.

Now he was ninety-four, and my anger and fear had vanished. I suggested a game of Scrabble and reminded him of my ruse and his response. He explained that he had told people I cheated because he was proud of me for recognizing the blanks. I understood that the remarks that had wounded me at thirteen were his rough way of saying that I had an artist's eye, just as he had when I was five. Also, I believe he was pleased with my deceit. I was a chip off the old block.

When I tape-recorded his stories, he remembered more than I expected. He asked how I had managed when I went out West by

The Great Turbino in 2004.
Photograph by the author.

bus after college. What did I eat, where did I stay? He said he hadn't asked at the time, because I "kept to myself." I replied that I had learned to take care of myself the previous year, when I had hitch-hiked in Europe for three months. Later, reflecting on this, I recalled that when I returned from Europe he hadn't asked how I managed then either. Was that also because I "kept to myself"? I guessed that phrase meant that I had never told him what I was doing or feeling. I was surprised that he, who had never communicated to me about emotions, easily put into words the distance I felt from him during those years.

I was touched. I recalled that Rich had once revealed that my father confided in him that he wept the evening before I went out West because he knew I was leaving home for good. I had had no idea he was aware of this turning point in my life and in his rela-tionship to me. And at ninety, forty years later, he still thought about this major event in our lives.

Once I asked him what had been the greatest change in his life-time, which had spanned a century—two world wars, the Great De-pression, the Holocaust, the New Deal, the assassination of a president and inspiring political leaders, civil rights legislation, Medicare, the collapse of the Soviet Union, the end of the Cold War, and the 9/11 terrorist attack. He had witnessed life-changing tech-nological inventions—"talkies," Technicolor, antibiotics, telephones, automobiles, television, jet planes, space travel, the Internet, and per-sonal computers. He said, "Women wearing pants." A year later, figuring that he might say something different, I asked him again. He said that I had asked him that before and that he had already told me, "Women wearing pants."

Occasionally he lost his balance, "took a flop" as he put it, then picked himself up and proceeded on his way. He had strong bones. In April 2005, at ninety-five, he had the flu, with fever, respiratory congestion, and a deep cough. He mistrusted the vaccine because "they shoot germs into you." In May, at Uncle Sam's ninety-fifth birthday celebration in Westchester County, he was pale, coughing, and had lost weight. The three brothers-in-law whose wives were gone, Sam Janis, Harold Fiedler, now eighty-five, and Bill Turbin, lifted a glass.

A month later, Ron phoned to tell me that Dad had slipped on wet tiles on his bathroom floor and broken a hip. In agonizing pain, he had crawled to the bedside phone; the attendants had called an ambulance.

Bill and I dropped everything and drove from New York to the Pittsfield hospital where my father awaited surgery. As I entered the room, I noticed a baseball game on television. I wondered if he was mentally alert enough to identify the teams, so I asked who was playing. He retorted that this was "the woist thing that ever happened to me, and you ask about a ball game?"

In his hospital bed, with his eyes closed and a Sony Walkman nestled near his pillow, he listened to recordings of his beloved Al Jolson songs: "Swanee, how I love you, how I love you, my dear old Swanee." He flirted with nurses. One asked him if she should call him Mr. Turbin. "Just call me darling."

A few days later a social worker took me aside and said that, when he recovered from hip surgery, he should move to a larger, more lively residence. Devonshire Estates was too quiet. "Your father is a force of nature."

Raising a glass at Sam Janis' 95th birthday party in May 2005

A few days after settling into a rehabilitation center near North Adams, he developed antibiotic-resistant pneumonia. In a hospital, the infection worsened. He breathed with rasping sounds, aided by a respirator. Because of a sore throat, he spoke in a hoarse whisper. Since swallowing food was painful, he lost weight and his dentures no longer fit. He had become a frail, toothless old man, with sparse iron-gray hair combed back, as always, from his face. In the daytime, he was alert, but one night he woke up unaware of where he was, tugged on his IV tubes, and attempted to get out of bed without help. Ron and I hired a private duty nurse to watch over him at night.

On July 6, 2005 (one of his two birthdays), Bill and I visited him

Carole Turbin, *Dying*, 2005. Pencil on paper.

in the hospital. He was ninety-six. Without a word, he fumbled under his bed coverings and pulled from the pocket of his hospital gown a false thumb and ropes, frayed and gray with use. As ill as he was, he had his magic equipment with him. He had spied a little girl with her parents across the room, by a grandparent's bed. I invited her over. As Bill and I filled in the familiar magician's patter, The Great Turbino, the illusionist, cut ropes into pieces and restored them. Then he changed a dollar bill into a twenty and back again.

Later that day he whispered to me, "I want to die." He was luckier than my mother. He was ready to go.

The following week, he was in a room for patients with highly contagious diseases. The nurse gave me a flimsy protective garment and warned me that he was unresponsive. I sat by his bed and held his cool, thin hand, as I had my mother's when she was dying. With each rasping breath, his chest heaved. His eyes seemed unseeing, but I felt that he was conscious of my presence. "Dad," I asked, "do you know I'm here?"

He nodded.

That was the last communication between us. I left the hospital feeling that I had said goodbye. He died in the early hours of the next day, July 12, 2005.

Bill and I went to the hospital as soon as I heard, before his body was taken away. I looked at his face in death, knowing I would sorely miss him. I reached for a sketchbook and a sharpened pencil, which I now carried with me so I could draw compelling images I wanted to fix in my mind. I sketched his eyes, closed and deep in their sockets, his sunken cheeks, and the lines around his mouth. The familiar moustache was gone, and only a few wisps of iron-gray

hair remained. His thin-lipped mouth was open, as if he were struggling to take another breath, to live another moment. As I drew, I saw almost a century of intense living, emotional highs and lows, ambitions, wheeling and dealing, finagling, disappointments, affection, ferocious anger, pleasure, and the ordeal of pneumonia. He was gone, but he had not disappeared. I remembered him in his prime, teaching me how to soothe my fears of the plumbing that moved in the night-time shadows.

"If you're afraid, draw it."

Carole Turbin, *The End*, 2005. Pencil on paper.

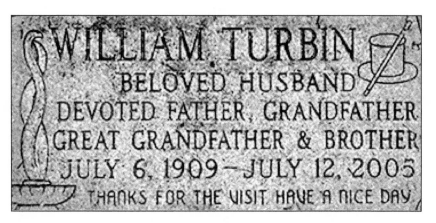

My father's gravestone

About the Author

Carole Turbin is a native New Yorker and lives in Park Slope, Brooklyn, with her husband, Bill Miller. In the 1960s she studied painting and drawing in New York and Berkeley, California, and after joining New York Radical Feminists decided to learn about woman's history. She earned a Ph.D. in Sociology from the New School for Social Research (1978) and then taught, researched, and published books and articles, including *Working Women of Collar City* (University of Illinois Press, 1992). In the mid-1990s she returned to art, became a lithographer, and has exhibited prints and drawings in the New York area.

CPSIA information can be obtained
at www.ICGtesting.com
Printed in the USA
FFHW021904240419
51993480-57400FF

9 781946 989291